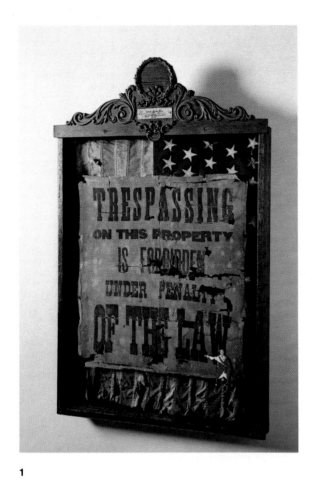

1

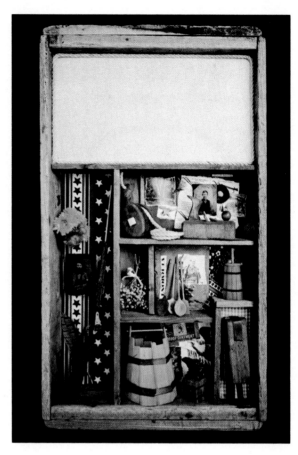

2

3

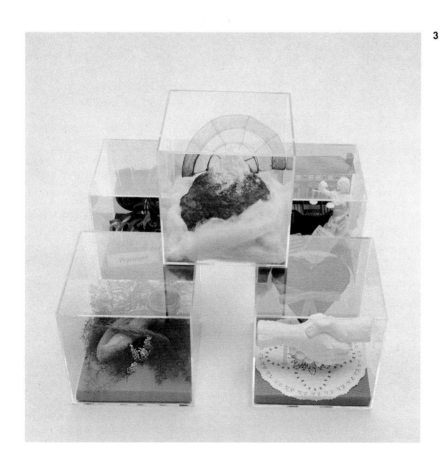

1
NO TRESPASSING
Collection of the Artist
18 × 25″
Photo: Cosimo Scianna

2
PAPERBACK LIBRARY
A. D.: Bruce Hall
19 × 24″
Photo: Studio Three

3
NEW JERSEY TELEPHONE CO.
A. D.: Glenn Kipp
Each cube 12″ square
Photo: Warsaw Studio

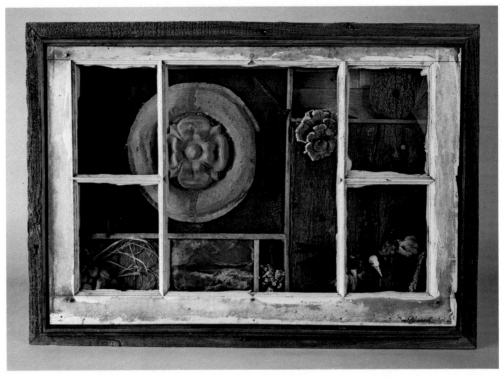

4

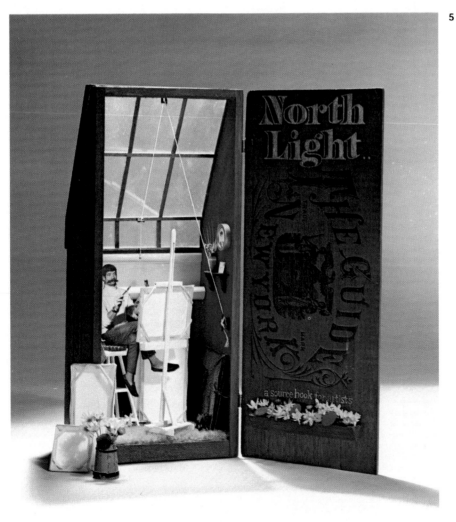

4
COLLECTION OF THE ARTIST
35 × 27"
Photo: Cosimo Scianna

5
NORTH LIGHT MAGAZINE
A. D.: Howard Munce
12 × 18"
Photo: Bill Joli

6
GOOD YEAR TIRE CO.
A. D.: Jerry Massina
Photo: Cosimo Scianna

7
RANDOM HOUSE PUBLISHING CO.
A. D. Susan Phillips
64 × 45"
Photo: Cosimo Scianna

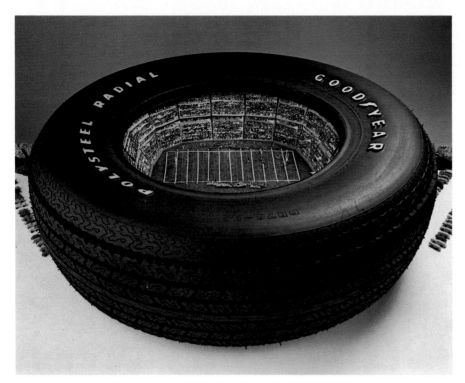

6

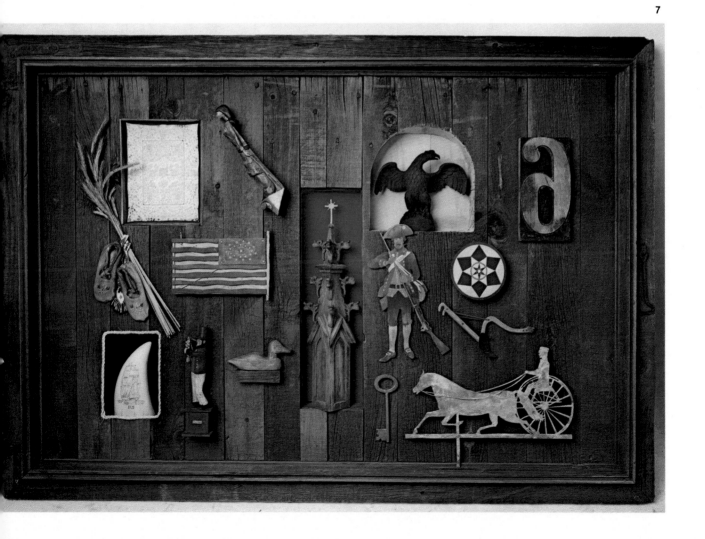

8

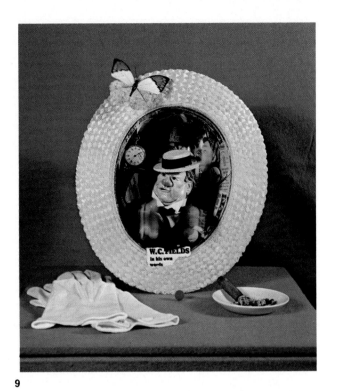

9

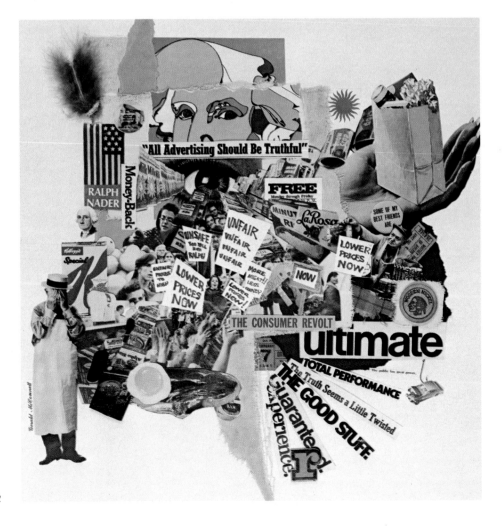

12

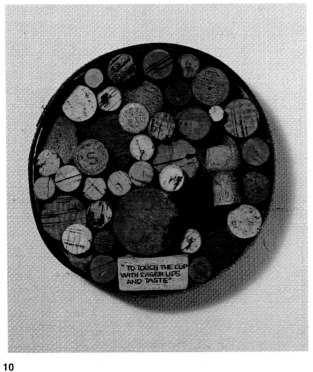

10

11

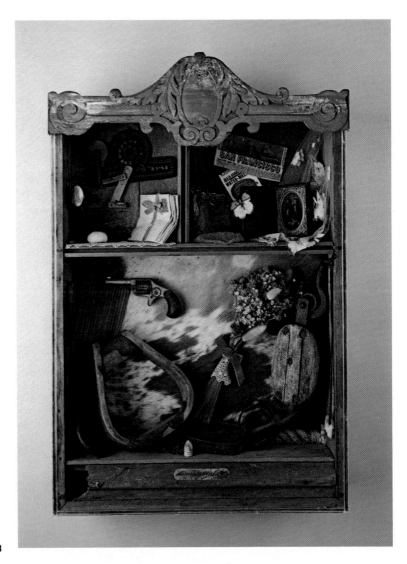

8
SIMON & SCHUSTER
A. D.: Milton Charles
12″ high figures
Photo: Cosimo Scianna

9
COLLECTION OF THE ARTIST
12 × 18″
Photo: Cosimo Scianna

10
COLLECTION OF THE ARTIST
12 × 16″
Photo: Photographic Color Specialists, Inc.

11
N. Y. DAILY NEWS
A. D.: Phil Ritzenberg
23 × 30″
Photo: Daily News

12
PRESIDENTS MAGAZINE
A. D.: Robert Geissmann
20 × 20″
Photo: Cosimo Scianna

13
BILL GOLD ADVERTISING AGENCY
A. D.: Bill Gold
19 × 29″
Photo: Cosimo Scianna

13

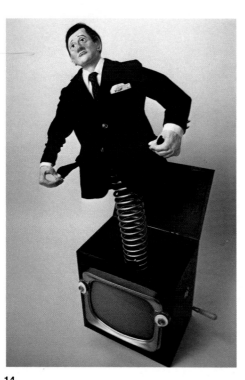

14

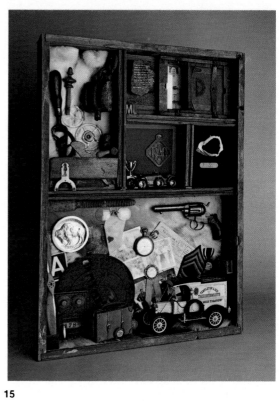

15

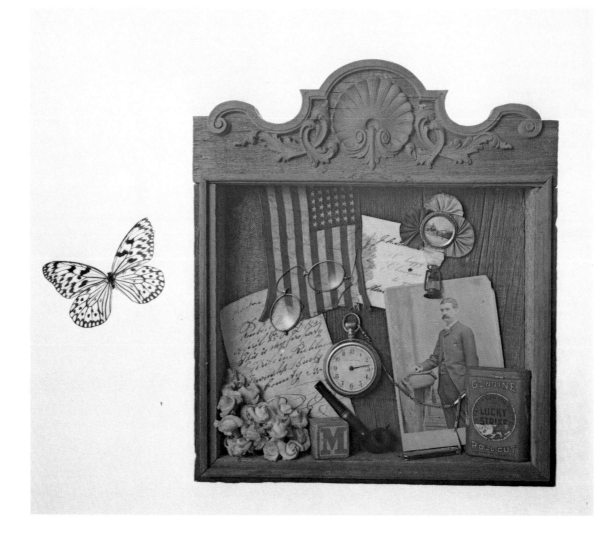

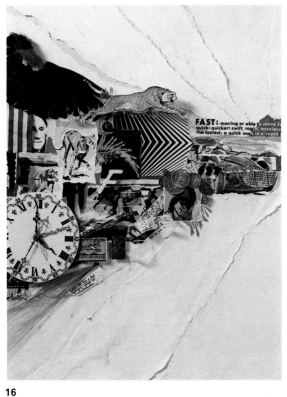

16

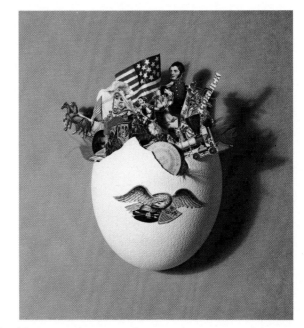

17

19

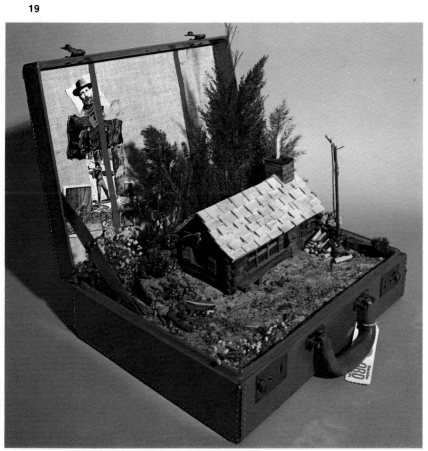

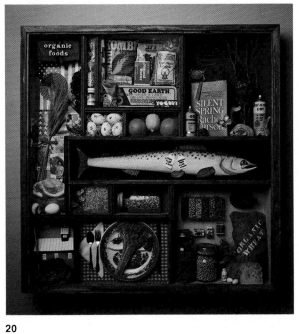

20

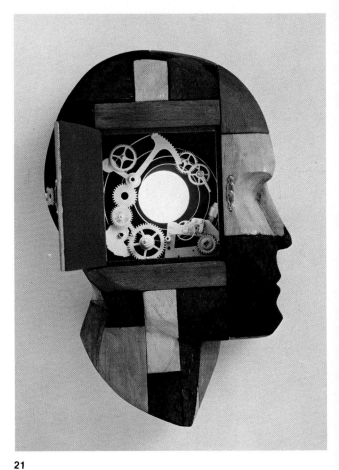

21

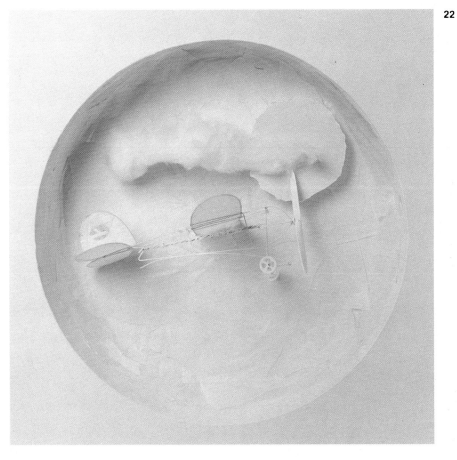

22

20
MEDICAL TIMES
A. D.: Howard Munce
40 × 40″
Photo: Cosimo Scianna

21
PAPERBACK LIBRARY
A. D.: Bruce Hall
9 × 12″
Photo: Cosimo Scianna

22
EASTERN AIRLINES
A. D.: Bernie Karlin
39 × 39″
Photo: A. K. M. Studio

Assemblage

Dedicated to
CHARLES RUSSELL McCONNELL

I would like to dedicate this effort to the one
person who had the greatest hand in shaping my
life, developing me in those traits necessary for
survival in a creative world. Aside from the ex-
perience of life itself, we also shared a love of
nature, creativeness, patience, craftsmanship,
and a true respect of tools. The few objects
on this page are about all the worldly goods my
father left me, but his real gifts are within me
forever, and my hope is that I can share them
with my children as he did with me.

ASSEMBLAGE

Three-dimensional Picture Making

Gerald McConnell

Designed and edited by
Howard Munce

VAN NOSTRAND REINHOLD COMPANY
New York Cincinnati Toronto London Melbourne

Library of Congress Catalog Card Number
76-4451
ISBN 0-442-25264-1 (cloth)
ISBN 0-442-25263-3 (paper)

Published in 1976 by Van Nostrand Reinhold
Company
A Division of Litton Educational Publishing, Inc.
450 West 33rd Street
New York, NY 10001

Van Nostrand Reinhold Limited
1410 Birchmount Road
Scarborough, Ontario M1P 2E7, Canada

Van Nostrand Reinhold Australia Pty. Ltd.
17 Queen Street
Mitcham, Victoria 3132, Australia

Van Nostrand Reinhold Company Ltd.
Molly Millars Lane
Wokingham, Berkshire, England

16 15 14 13 12 11 10 9 8 7 6 5 4 3 2 1

Library of Congress Cataloging in Publication Data

McConnell, Gerald, 1931–
 Assemblage: three-dimensional picture making.
 1. Collage. 2. Assemblage (Art) I. Title.
TT910.M3 702'.8 76-4451
ISBN 0-442-25264-1
ISBN 0-442-25263-3 pbk.

CONTENTS

ACKNOWLEDGMENTS

I would like to thank Bill Fletcher for starting
me on this project, Jim McCartin for his efforts in
the embryo stages, Cosimo Scianno and Bob
Marchetti for their efforts on the photography,
Howard Munce without whose contribution
there would have been no book, and Arpi
Ermoyan who can translate almost anything
into English with her trusty electric typewriter.

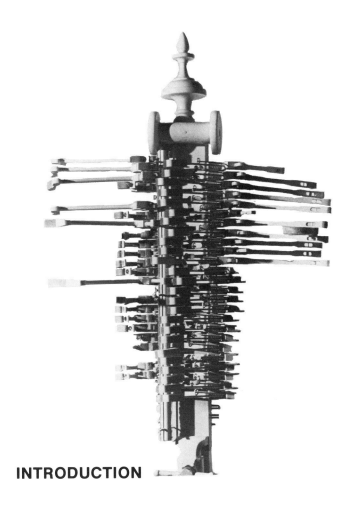

INTRODUCTION

It's my hope in writing this book that I can open up for you a pleasurable world that you may never have known existed or have lacked the confidence to explore.

All you need bring to our association is an enthusiastic spirit, a minimal handiness with simple tools, a pack rat's instinct for collecting things, and as modest or monumental an imagination as you may possess.

Armed with the above, you can soon experience the same pleasure that it has been my good luck to have enjoyed all my professional life.

Not only will you delight in what you'll be able to create, but you'll be amazed how equipped you are at this very moment to enter the happy world of collage and assemblage.

At this instant, lying dormant in your dresser drawers, attics, cellars, hope chests, trunks, scrap books, and pigeon holes is a treasure trove of trinkets and memorabilia waiting to be brought to light, reexamined, juxtaposed, and affixed.

When you've made your first collage or assemblage, you will not only have had the lovely pleasure of *doing*, you will also have expressed yourself and given new meaning to your possessions. You will have commemorated in one unit many parts of an experience that is sentimentally precious to you or to the person to whom you may present the piece.

Most important, whatever the occasion, you will have fashioned a one-of-a-kind original work—the kind of nonstock item that can't be bought at a gift shop. Huzza!

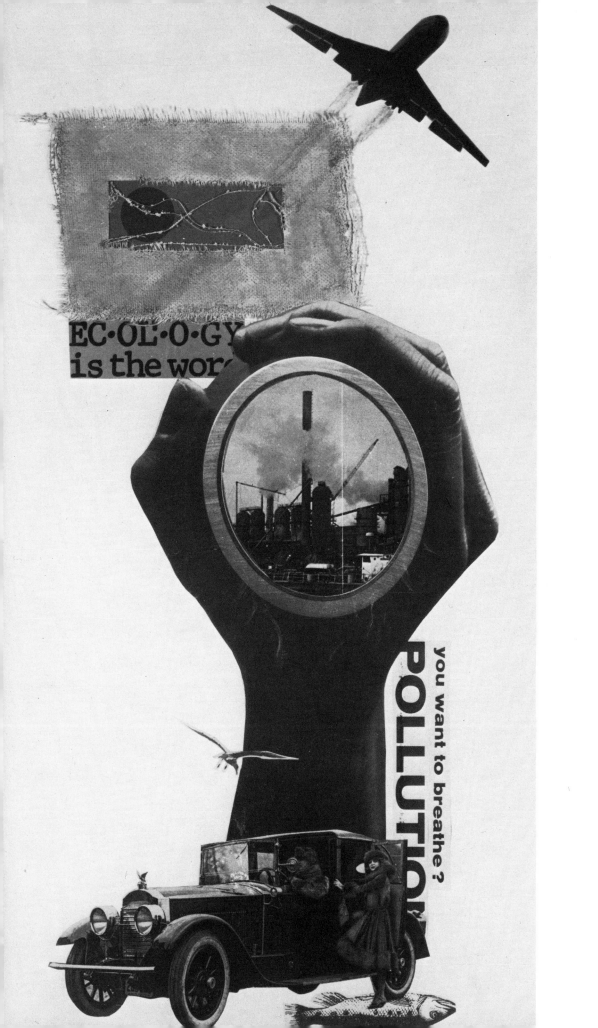

COLLAGE AND ASSEMBLAGE

Without realizing it, you have already worked at both collage and assemblage long ago as a school child.

It was probably in a very simple form—colored paper, marginal cutouts, cardboard Santa Clauses, or maps. In any case, if you selected flat things, decided on their position, and then pasted them down, you made a collage. *Collage* is a French word that means gluing. If you used bird seed, stones, macaroni, Cracker Jack prizes, plastic charms, or other three-dimensional objects and assembled them, you have performed in French again. Their word for this is *assemblage*. Both forms came into prominence during the Cubist movement in Paris. Braque and Picasso were two of their most innovative exponents.

The fact that a child can easily make a pleasing design is not as surprising as it might seem. Children are not inhibited in matters of design. They know which colors and compositions please them and aren't worried about realistic representation. They aren't bothered in the least by the fact that they've never seen a green dog or a puppy the size of a man. When children work on a picture, suggestion and design are much more important than considerations of accuracy.

Generally, collage can be regarded as a form of painting while assemblage is more nearly like sculpture. More sophisticated pieces often overlap the two: a collage may include objects that are three-dimensional and an assemblage may incorporate a collage. Collages and assemblages can be representational or abstract, serious or funny, or anything in between.

So, you can see this is a merry corner of the world in which to work. There are no rules except the rules of good craftsmanship, and these are not only a matter of good sense but, just as important, a matter of pride. Sloppiness and haste are two ways to insure misery and poor work.

I happen to use both collage and assemblage commercially because they allow me much more range in solving visual problems. With the added dramatics of lighting, movement, and photography, they also lend themselves to today's exciting graphics. Maybe this application doesn't interest you. Perhaps you are only concerned with exploring a new facet of art technique. Fine! Collage and assemblage have endless avenues of creative possibilities to offer. I shall introduce you to a few, and I hope at the end of this book you will be excited enough to make collage and assemblage a continuing part of your visual life.

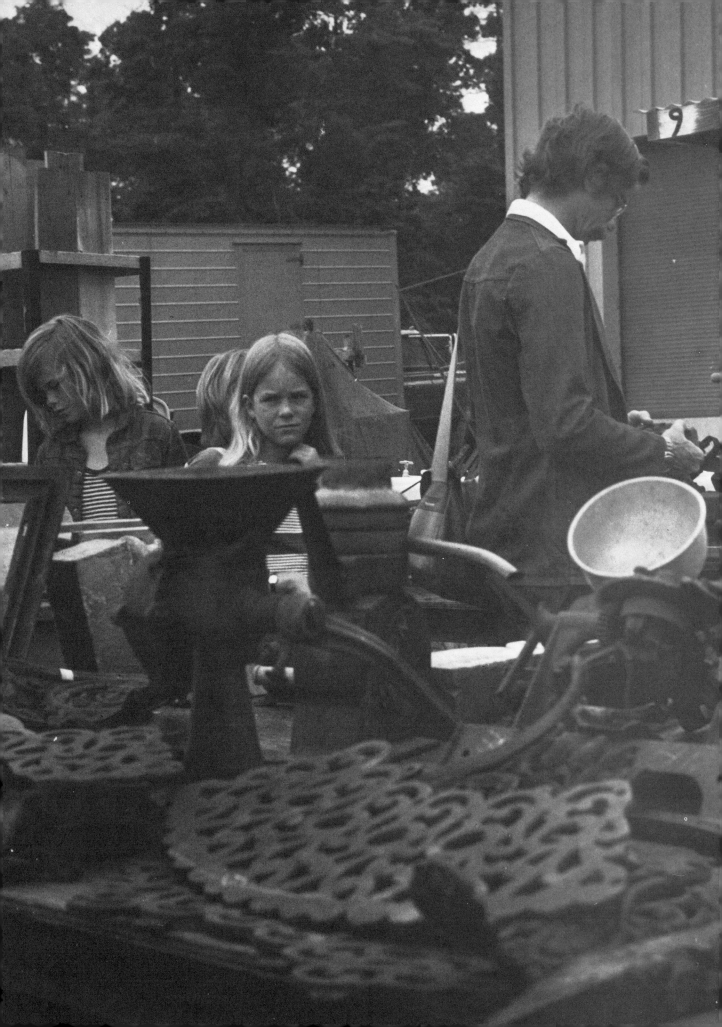

CONFESSIONS OF AN ADVANCED STRING SAVER

Like all illustrators, I have always kept a scrap file. It cannot be lived without! One day you are apt to need to know how the horns curl on a Rocky Mountain goat and the next assignment may call for you to portray a street cleaner in Brisbane, Australia.

With luck and a good collection of old *National Geographics*, you'll live to panic another day.

My scrap file started simply. At odd moments I would go through *Life*, *Look* (how I mourn their passing) and *National Geographic*, clipping pictures which might be of help to me. Later I sought more specialized magazines such as *Scientific American*, *Car and Driver*, *Yachting*, and professionally oriented periodicals.

As my collection of clippings grew I realized that it would save me additional time if the clippings were separated into categories. I now maintain these clippings in folders under headings such as Animals, Transportation, Uniforms, Children, Weapons, etc. They fill two legal-size file cabinets. The odds on being caught unprepared are now in my favor.

Now that I work in collage my reference file must serve an additional function: the clippings become part of the artwork itself. This means that I have to collect even more material than in the past, and, in fact, have had to start several new categories for my files. For instance, I now keep many bits and pieces of colored paper and wallpaper samples, pictures showing objects in unusual sizes (such as a very large photo of a nickel or bottle top) which can be added to a collage in a dramatic way. Also, now that I use these files as the main source for my collages, it means that the particular piece of scrap will be consumed and this in turn depletes the files.

So the gathering never ends, and though it can be a pain if unclipped magazines pile up, it is also an interesting chore because you notice things more keenly the second time you go through a book.

But chore or not, a good, fat file is indispensable.

COLLECTING COLLAGE MATERIALS

There is virtually no limit to the materials which can be used in collage, except that they must be sufficiently lightweight so that they can be glued to an almost flat surface. You will undoubtedly make most of your collages out of material such as old newspapers and magazines, colored paper, bits of cloth, etc. Elaborate collages can be made since there is such a great wealth of material you can use, including your own drawings and paintings. Your new-found friend, the scrap file, of course will be a major supplier of needed items.

I call bits and pieces of odd materials that are used to brighten up a picture McConnell Confetti. A bright piece of ribbon or a fragment of gift-wrapping paper may be just the item you need to highlight an area. Sample books of color tabs and swatches from fabric stores also can be used to create visual interest simply because they're different from the other materials used in your work. What *your* confetti consists of depends on you. The important thing is to save anything that excites you visually: A *use* for it will turn up sometime later. I have stashed away hundreds of pieces of cloth, old Christmas cards, yards of ribbon and yarn, metallic papers, Valentine cards, and old sheet music. Bits of clothing can be used in collage—in fact, whole collages can be made exclusively from scraps of cloth. So stay your mate's hand when he or she tries to get rid of certain old garments.

The scraps you maintain in your confetti file will usually be small, since their purpose is not to dominate the collage, but to be used decoratively. Other items I find useful are postage stamps of all kinds, party favors, anything decorative having a special theme, colorful tickets, and buttons, especially political and message ones (though *some* recent messages might better be left out). I also have a good collection of dried flowers and plants which lie quite flat but can add great color and texture. Butterflies are among my favorite items and are readily available in all sizes and colors. I have many types of ribbons, ropes and strings of varying sizes and colors, and a large supply of rub-off type in many faces and sizes for adding just a line or word when needed.

Most of my collages are made on assignment with a specific theme in mind. For instance, I may be asked to do a cover for a Saint Valentine's day issue of a magazine or one to illustrate the annual report of a chemical concern. When I receive such an assignment, it saves me invaluable time if I have what I need on file. Even if one doesn't have a specific item, just going through the subject file often promotes ideas you otherwise might not have thought of—hearts and lace or covers for Valentine's day; beakers, Bunsen burners, or cracking towers for my chemical client.

In addition to the filed material, I always keep the last six months' issues of the most popular magazines lying around the studio to browse through, and these often yield equally valuable material. When you've been through all your material and find you still need more, you must then start searching back-date magazine stores or the library, where you can often find material that you can photostat. This is especially true of period subjects.

As you progress it is likely that you will decide to make collages for specific occasions or to be used in a particular room. You will then want images in the collage which suggest the specific occasion or room. A collage for the kitchen, for example, would probably include pictures of food or cooking utensils. One for a man's den would undoubtedly include masculine images portraying the outdoors, cars, machinery, or, if the man has a specific hobby, images of that hobby. For this reason it is helpful to have a "theme" or "idea" scrap file for pictures or designs which especially suggest a theme. It has been my experience that these "symbols" should be simple. For a Saint Patrick's day collage, a shamrock is unmistakable, while a picture of the Lakes of Killarney might not be. A heart suggests Saint Valentine's day; a bunny or chick suggests Easter; Santa Claus, Christmas. That's not to say other symbols will not work well. It's just that, in general, well-known symbols work best. If you start with an obvious symbol to get the idea across quickly, then you can use less obvious ones. On a Saint Valentine's day collage I might use bits of old lace, but I would also use the heart shape somewhere so that my theme is clear to everyone. Similarly, for a collage to be used in the kitchen, I would surely include food or kitchen utensils. Then I would feel free to include any other items which might be used in the kitchen. The word "tarragon" would be a nice touch to a kitchen collage, once it's *clearly* a kitchen collage, but to someone who doesn't know what tarragon is, it would not be sufficient to suggest the theme.

Storage space is practically everybody's problem. It surely is mine, so I maintain a directory on where to get special things that I may need someday but am unable to store. Whenever I pass a store which handles items I feel could be useful, I write down the address and a description of the merchandise. By now, I have a pretty good *Yellow Pages* of my own. I can let my "fingers do the walking." New York is great in this respect—it has almost everything and you can usually find either a manufacturer or importer who handles the items you want. I have always found them most willing to help.

The Public Library in New York maintains an extraordinary picture and magazine collection which I use quite often. From library files you can obtain the name of the publication and date of issue, and then go buy the magazine from one of the many back-date magazine stores. *The New York Times* also has a back-issue service. They have many fine photos from the past and always, of course, the fashions of whatever period you need.

To supplement these sources there are professional reference concerns in New York such as Culvers or Bettmann Archive Inc. who have thousands of odd subjects cataloged and ready for use. News services will provide photos of sports and news events, and public relations departments of almost any business will also have photos and publications on hand pertaining to their products. Finally, the U.S. government maintains quite a supply of material on various subjects, which is obtainable for the asking.

One of my assignments had to do with the Peace Corps in Afghanistan. There was so little that had appeared in print at the time on this subject that

things looked lean as far as collage material was concerned. I finally called the Peace Corps in Washington, D.C., explained my problem, and by return mail received enough good material to do two or three collages. I think the key to good research is just to keep digging, no matter how futile it appears at times. Being a persistent pest wins out in the end.

Of course, not everyone has access to many of the services available in New York City, but many large cities now have their own peculiar sources. If your community doesn't, it behooves you to outwit the problem by saving everything you can get your hands on. Happy storage!

COLLECTING ASSEMBLAGE MATERIALS

Searching for, collecting, and saving assemblage material is a more complicated business. Better you should live in a boxcar because, when the junk-bug bites, you'll lose all resistance to ever saying "No" again.

I've been hooked for years and am hopeless now, as the photos in this chapter will attest. They were taken at the United Homewrecking Company in Stamford, Connecticut, a place where I deposit more money than I do in banks. This is a very sophisticated place with only the most desired items. I've never yet come away empty-handed. Wherever you live there will be its equivalent nearby—junk yards, second-hand stores, Goodwill Industries, Salvation Army, thrift shops, etc.

If you're interested in this kind of work, I'd advise you to start haunting the place now to supplement what you don't happen to have in your attic or basement.

I must warn you, however, that you'll cry out in anguish when you see the prices of some things identical or even inferior to things your mother or grandmother once tossed out as "that old junk." I have died a hundred such deaths. I mostly buy the better things for a specific job. Often on a commercial assignment where money is no object, I buy from good antique shops if that's the difference between an exquisite item and an ordinary one. And because of price, one is not apt to stock such things in large numbers.

However, there is a raft of stuff I *do* stock for assemblage—such things as old windows, frames, cookie and cake tins, weathered ropes and boxes of driftwood, corks, shells, all sorts of dried plants and flowers.

I also have a whole box of things to simulate ground and ground cover: many different types of rocks and minerals and artificial grass, and several types of soil. I have found that soil tends to dry out and lighten in value, so I use a type of plant-food enricher that I can get at the five-and-ten-cent store.

It stays dark and rich-looking. There are also many types of sand from white to black which can be mixed with soil to vary the shade. There is a moss which on a small scale looks very much like either trees or bushes and comes in colors. It is used by model railroad people but works well for the artist too.

I keep a stockpile of other materials, from leather to the finest lace. New materials are now made to simulate fur, and I use them in animal construction. Fabrics come in endless color ranges and patterns—the variety is unlimited.

One of my largest collections is old wood, which has a charm that is hard to imitate. I started with old wooden cigar boxes, of which I now must have twenty five or thirty. I've used quite a few for different assemblages, both as ready-made boxes and as wood stock, since the wood is easy to work with and has a built-in patina. I also have many types of drawers and containers and a fair collection of plain old wooden boxes and sundry things that seem to have potential. This includes old lathe-turned pieces, such as chair and table legs. In storage around New York I have found and bought loads of different items. Among my treasures are an old hatch cover from a ship, an ancient dressmaker's form, a rickety old bait trap, some old trays used by a baker, cheese boards, etc., all of which I hope will one day lend themselves to a specific job. I have files on everything and try to keep them all in mind when working on new assignments. One never knows when something will be just the right item.

Naturally I use a lot of paper. Mostly I work in one-, two-, or three-ply papers for construction and on smooth Bristol or bond. However, I have a six-drawer file full of every conceivable type of paper.

As you might guess, it would not be advisable to turn to this kind of work if you live in a furnished room or on a small boat.

This is a pursuit that depends on "*stuff*." So beware, all you fastidious, neat people who can't stand "things lying around." More important to all unmarrieds—check out your prospective mate about his or her views on closet space before you tie the knot. (Incidentally, I have a whole box full of old knots!)

WORKBENCH

This is my workbench, arranged according to my needs. I've had a dozen set-ups before this, and each time I've designed it according to the available space—usually very limited. Now at last I have a new studio in a vast loft and for the first time I've been able to spread out and have things exactly as I want them.

In addition to this general bench, the table saw and the band saws are in their own individual spots, and I often set up auxiliary benches on which I assemble a piece. This keeps the workbench free for fashioning things and at the same time it keeps nonessentials out of the way of the piece being assembled.

Clutter is very detrimental to neat work. And with sharp tools lying about, it's also dangerous. More important, it bothers me.

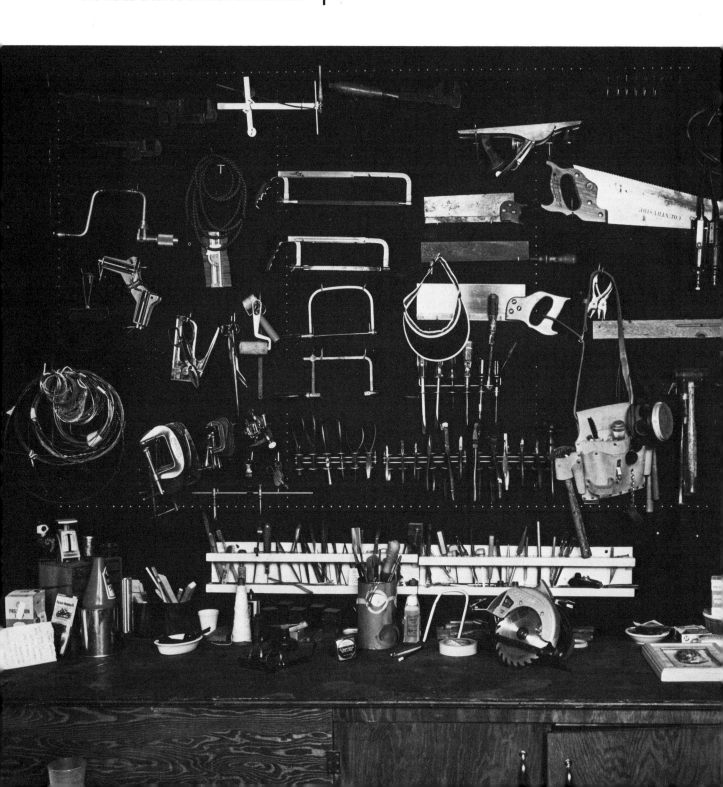

TOOLS

My training in working with my hands and using tools started about as early as possible. My father always built things and as soon as I could get my nose above his bench, he allowed me to help. He was a man who believed that only your best effort was acceptable, so he taught me to work carefully and exercise patience, and encouraged me to try again. This example was always there to remind me that haste usually does make waste and that patience and good planning are my two best assets in the precise work I do today. My father was very influential in instilling in me the pride of good craftsmanship and the value of caring greatly about the final product. It's one of the things I find maddening about having things made by specialists in certain areas of my business. There is an increasing lack of pride in workmanship. Too many so-called craftsmen spend their energies working on the improvement of their price lists!

Tools, of course, are all-important in assemblage. Your collection will depend largely on the size and nature of the materials you work with. Obviously, if you make your assemblages all out of metal you will need a collection of tools for that purpose. If plastic is your favorite material, a different set of tools will be necessary. Most of my work is done with materials of a soft nature, either wood or Foam Core. Both are easy to work with and can be quite durable. Almost everything I have made could have been done with a set of model-maker's tools such as X-acto manufactures.

A hand power tool, such as the Dremel, is readily available and wonderfully versatile. It sands and does fine drilling. It is designed primarily for small work and usually has a power foot control to allow you to have both your hands free. I have a normal one-quarter-inch power drill, an electric table saw, and two portable power saws. It's amazing what these tools can accomplish. I find tweezers are a way of life, almost! I have several—some with side locks to allow holding without using constant pressure and some long ones for retrieving things which may drop in hard-to-reach areas. I also have several dozen small clamps ranging in size from a one-inch opening up to three or four inches. These save a great deal of time when gluing and help make better bonds. A selection of holding jigs which are mostly ball-jointed allow you to hold objects at odd angles for gluing or soldering.

In some cases my needs for special tools go beyond the average model maker's. Then I visit the jewelry center and adapt some of their tools to suit my purpose. If this doesn't do it, I use one of the companies dealing in miniaturized tools, such as Allcraft in New York, or a mail-order house such as Brookstone in New Hampshire. From places of this sort you can get everything from snap-fastener kits to flexible files, three-way clamps, and even cleaver plates, which can be used to make hundreds of different wood joints.

Get in the habit of sending for catalogs of off-beat tools and materials—they often save the day. It's probably folly to advise anyone of exactly what tools to collect. Chances are good that if you're interested in this kind of work, you are already a hardware freak and nothing I say will stop you from

CLAMPS

These are just a few from my large collection of clamps. I have several duplicates of each type. Certain clamps of a certain size save the day by being *exactly* right for the job at hand.

There are many other types not shown here: large wooden ones for furniture, for instance, and other metal ones. They are *all* right for certain situations—either to hold parts together until the glue dries or to free both hands while you perform other tasks.

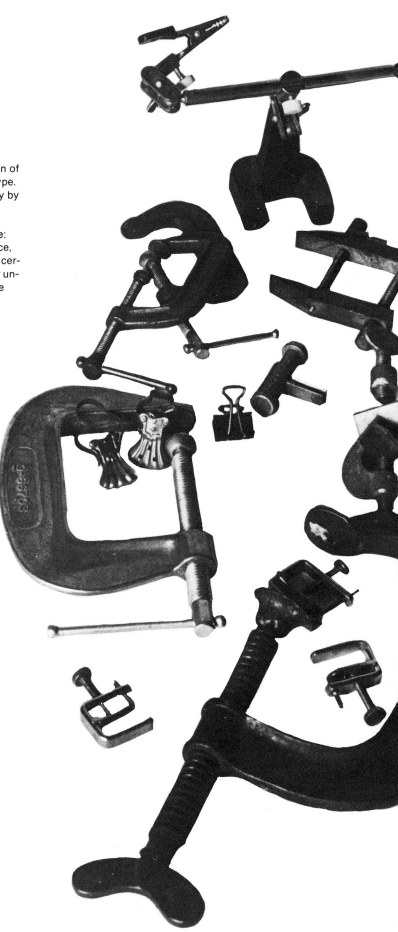

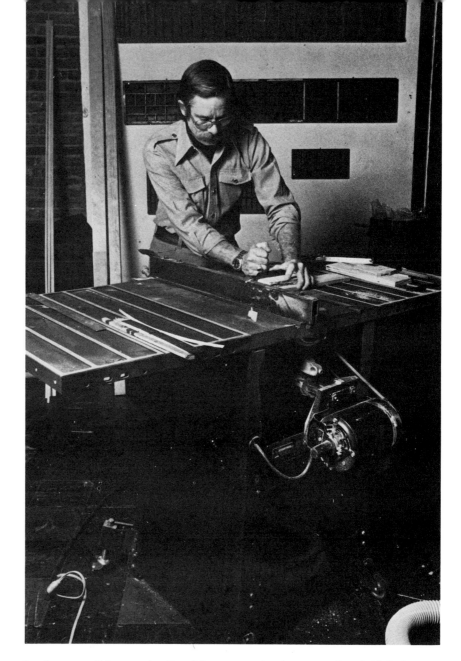

buying everything made. Good for you and welcome to the club! Only a limited workshop area has prevented me from bankruptcy.

Pushpins are a great invention and an indispensable aid in keeping things in place while glue is drying. They also hold things together when you are making a mock-up. Emery boards make good sanding tools for many of the materials I work on. They are flexible and can be cut to fit odd-shaped areas. Toothpicks are also good standbys. I use them as pegs, to reinforce things, and to apply and clean up excess glue.

One or two small vises are necessary and I have found that padding their jaws helps prevent marring the material. You will eventually assess which tools are really needed for each job and will build up your supply in this manner. It's imperative to have the right tool for each job.

As I have said, most of the materials I use are basically soft. They're right for me mainly because of the speed with which they can be worked. Most of what I do is determined by the deadline. But don't *you* worry about speed if you don't do commercial work.

I'm always open to something new. I try to spend part of each month checking on new products and maintaining notes and files on them. When the call comes I like to be able to reach in and get cracking!

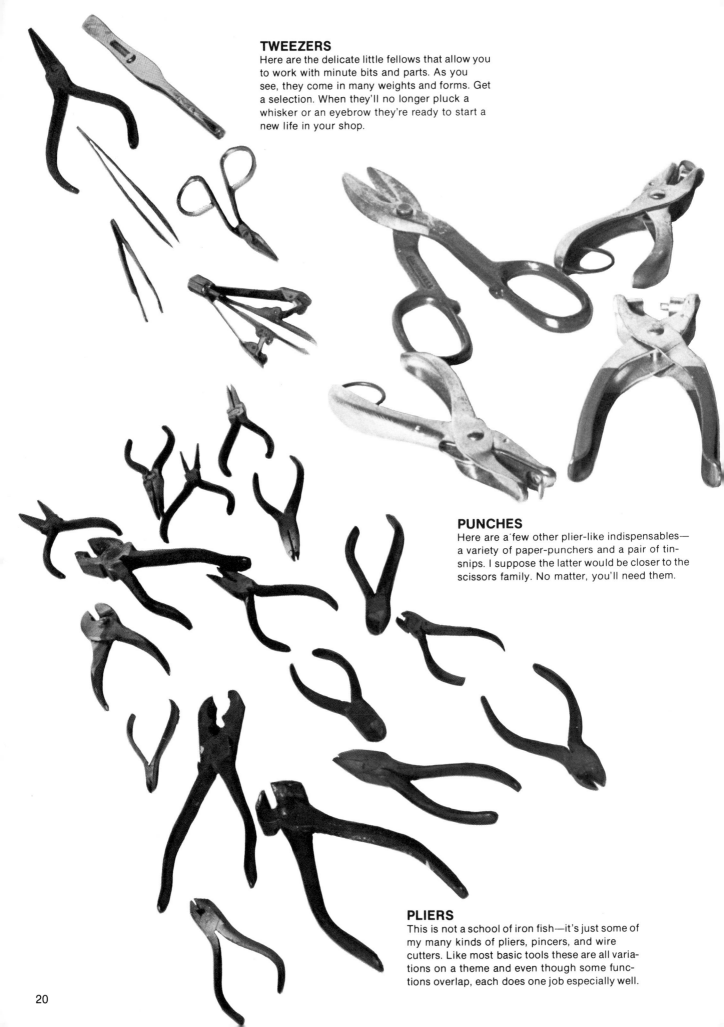

TWEEZERS
Here are the delicate little fellows that allow you to work with minute bits and parts. As you see, they come in many weights and forms. Get a selection. When they'll no longer pluck a whisker or an eyebrow they're ready to start a new life in your shop.

PUNCHES
Here are a few other plier-like indispensables—a variety of paper-punchers and a pair of tin-snips. I suppose the latter would be closer to the scissors family. No matter, you'll need them.

PLIERS
This is not a school of iron fish—it's just some of my many kinds of pliers, pincers, and wire cutters. Like most basic tools these are all variations on a theme and even though some functions overlap, each does one job especially well.

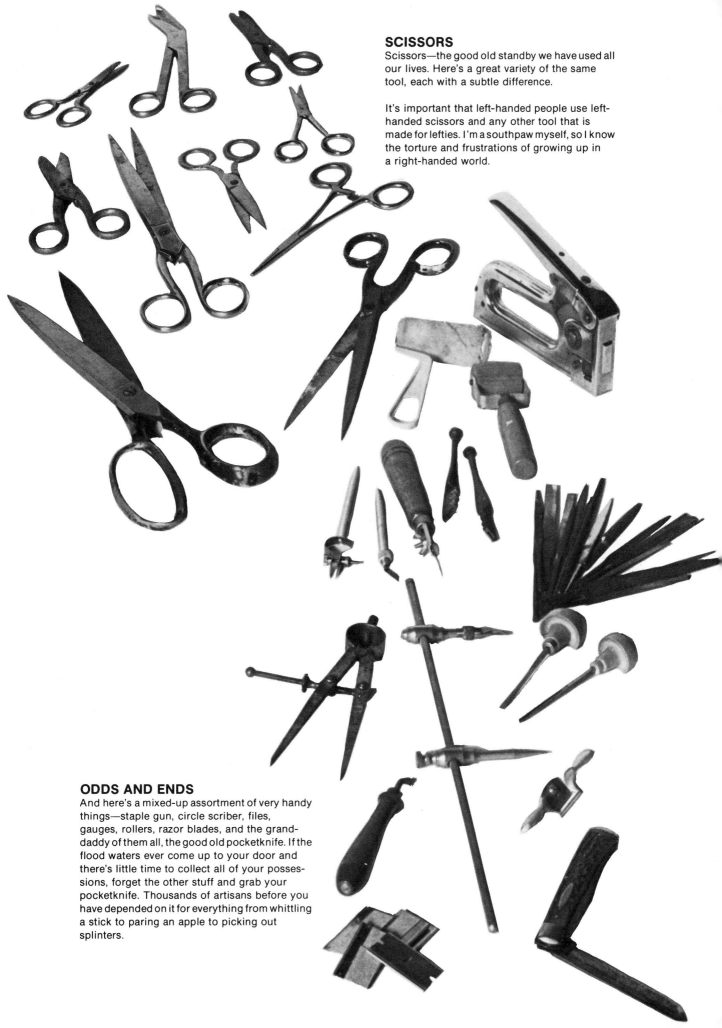

SCISSORS

Scissors—the good old standby we have used all our lives. Here's a great variety of the same tool, each with a subtle difference.

It's important that left-handed people use left-handed scissors and any other tool that is made for lefties. I'm a southpaw myself, so I know the torture and frustrations of growing up in a right-handed world.

ODDS AND ENDS

And here's a mixed-up assortment of very handy things—staple gun, circle scriber, files, gauges, rollers, razor blades, and the granddaddy of them all, the good old pocketknife. If the flood waters ever come up to your door and there's little time to collect all of your possessions, forget the other stuff and grab your pocketknife. Thousands of artisans before you have depended on it for everything from whittling a stick to paring an apple to picking out splinters.

GRAPHICS

As you can see, there is an endless variety of graphic material available for you to call upon when you want to use letters, numbers, and words in your work.

And don't forget, there is always hand-lettering, if you can do it, and the local sign shop, if you can afford it. But, with all the possible type forms to be easily purchased, I think you can fill most of your needs yourself. It's surely a lot more satisfying when you do.

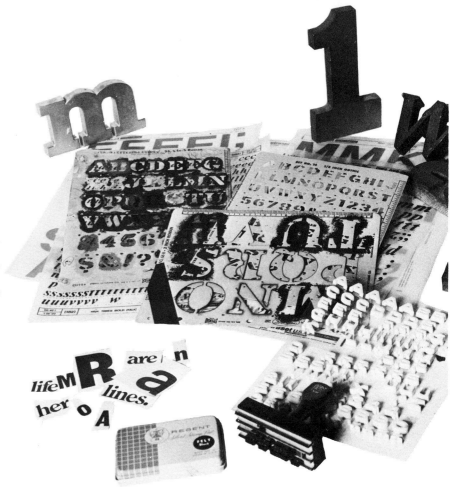

TYPE

If you work in collage or assemblage it's inevitable that you'll become involved in the use of words or initials or letter forms. Often you'll want to express a sentiment, use a quote, or state a name. In any case, you'll need an alphabet of some kind.

Of course, you can often hand-letter your sentiments, but that's a difficult art for an untrained person, and crude lettering can spoil the look of your work. Also, you'll discover that you often want the letters to appear on some material upon which you can't letter, like sand or coffee beans, for instance.

Happily, there is a world of solutions to the use of letters or words. Here's a list that will see you through most problems.

RUB-OFF TYPE

You can now get an endless variety of rub-off type faces in all styles and sizes at art supply stores.

They come in two general forms: one has the letters affixed to a sheet of transparent waxed paper. You simply lay the sheet on your working surface, hold it firm, and rub the top side with a pencil or a rounded tip of some kind. Pressure transfers the letter. Use care in lifting the waxed paper. Set your next letter in place and repeat the procedure.

A few of the brand-names for this kind of product are Prestype, Letraset, Cello-Tak, and Formatt.

Black is the most common color, but they also have faces in white, red, and gold.

A relatively new product is called Letrasign. In this case you buy a small packet of individual letters, peel off the waxed backing and press the letter down. There are many advantages to this product. First, it comes in much larger sizes than the transfer type. Then you have the advantage of being able to lift and move the letters, if you wish. It's expensive but excellent.

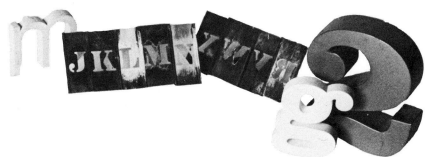

CUT-OUT LETTERS

Make yourself a file of printed letter forms that appeal to you. Cut them from newspapers, magazines, catalogs, old posters, and mailing pieces. Old Christmas cards are an excellent source, too.

In addition to stocking what you may one day need, you'll find yourself gaining interest in lettering and type. Encourage this interest. It's a rewarding pursuit.

STENCIL LETTERS

All your life you've seen examples of this form of printing and have probably never thought to admire it.

You've seen it on packing cases everywhere, and anyone who's ever been in the military service has had his name printed this way.

It's done very simply: the letters of the alphabet are punched out of a sheet of impregnated cardboard. You hold the sheet flat on the surface to be printed, daub paint or ink in the open space, and then move on to the next letter.

A more sophisticated form is a box of individual letters, punctuation marks, and numerals stamped out of thin brass. With these you first pick out the letters that make up your word, then slide them together on their slotted edge and do a whole word at a time. These are sold under the trade name Lockedge.

I recently discovered that the cardboard kind now comes in sets. The styles vary a bit and, more important, they have a good size range and are very in-expensive. I bought mine at the school supply counter. They're made by the E-Z Stencil Co., Baltimore, Maryland. They're also made by Dennison and Stenso.

RUBBER TYPE

Remember the toy hand-printing set? These consist of individual rubber letters mounted to a wooden holder. You press them to an inked stamp pad and then to a surface. They are limited in size and variety, but do include quaint extras such as pointing fingers, arrows, flowers, and other unusual decorations.

And don't forget you can have special rubber stamps made up to say anything you please. Most stationery stores take orders for these stamps. They'll show you a catalog from which you pick your own type faces and sizes.

WOOD TYPE

Until a few years ago most printers kept a stock of old wood type on hand for special jobs. Suddenly it became fashionable to buy it up and use it decoratively.

Between the fad and the sad fact that much of it was destroyed as useless junk, it is now in limited supply. But if you can get your hands on some, do, because it's great to hand-print an occasional letter with or to use as an object in an assemblage.

THREE-DIMENSIONAL LETTERS

There now exists a large choice of letters made from many materials—wood, ceramics, plastic, and metal. These letters come beveled, square, sculpted, rounded, painted, unpainted, and in all sizes. They can be obtained from sign shops.

Don't forget that hardware stores also carry letters and numerals for use on mail boxes and lawn signs. There might be occasions when these would suffice.

ADHERENTS

These are the bonding agents I took off my shelf when the photographer came to shoot the pictures for this book. And there are many, many more varieties.

Buy anything you see that might perform a special function. It's always a great feeling to reach for something and have it just when you want it. This is one area where prices don't get too high, so you can afford to stock up a bit.

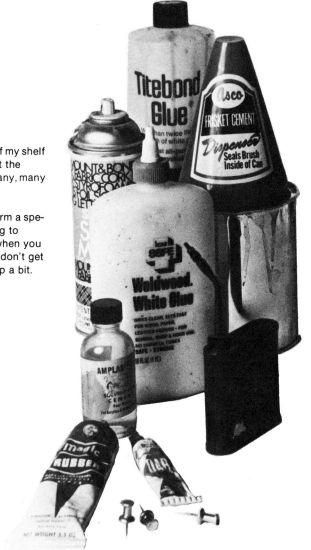

ADHESIVES

Of all the many materials you will deal with in the making of collage and assemblage nothing is as necessary and important as the glues you use.

You should stock up on all kinds now on the market—and there are many, designed for many different purposes. There are some for porous and non-porous surfaces, some for plastic, and even some which work well on metal.

I keep about seven different ones in my studio, all formulated to give a sure bond to a particular material. In this kind of work things must hold fast or your small world will come down around your feet like a house of cards.

A happy recollection of my childhood is helping my dad build furniture. My job was to stir the glue which we concocted ourselves from an animal derivative. I remember with revulsion how sticky and smelly it was. There's no need for nose-holding any more. Today I use prepared glues. The one I use most is Elmer's, which has a casein base made from milk. Most of the materials I work with are porous, such as balsa wood, paper, cloth, etc., and I have found that Elmer's does an excellent job.

After cutting, sanding, and prefitting, you'll be ready to start gluing. Pour a little glue onto a piece of cardboard, just as much as you'll need at one time. Use toothpicks as applicators, being careful to use as little glue as possible. Have several clean toothpicks handy to pick off the excess. After applying the glue to one surface touch the two surfaces together, separate them quickly to make sure the glue will transfer uniformly, and smooth it out with a toothpick edge so a very thin layer remains. Then quickly press them together for the bond. Hold the pieces together for thirty seconds, or until you feel that the glue is drying. Then lay them aside for three or four minutes to set. Patience is the key. Slow down. Think beautiful thoughts. Let the glue dry well.

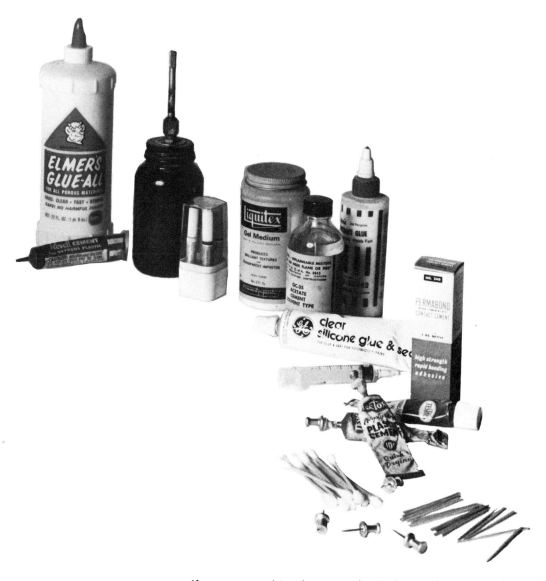

If pressure and tension are going to be exerted on two pieces from their own weight, build a jig to hold them together while the glue sets. Use push-pins to hold the pieces. By using a minimum of glue you will find that it sets quickly. If you overdo it, you merely force the excess out of the bond area and over everything else. Even with care a bit often squeezes out. This can usually be removed with warm water and a cotton swab. However, if you've gotten glue on the surface of cloth or paper with a finish, your job can be a lot tougher. You should first let the glue dry; then, if it's still visible, try to remove it by cutting or scraping. Be careful and keep these problems to a minimum.

When gluing two larger paper surfaces together, I recommend Elmer's glue instead of rubber cement. The latter, though a fine adhesive, has a relatively short life. In time it loses its bonding power and after several months it often discolors the paper and plays other dastardly tricks. This is also true of some paper glues on the market. For one reason or another I have found most of them not as satisfactory as Elmer's. To join large pieces of paper together, prefit them to be certain of their placement, then mark the one which will hold the glue. (Usually the one to which the glue is applied will buckle slightly, so if you don't want it to show, make it the base.) Measure the glue into a paper cup and dilute it ever so slightly with very warm water. Put a little of this mixture in the center of the base shape and spread it into a thin layer with a squeegee-type tool. If the area is an extra large one do it in sections to avoid the need to rush to make the bond before the glue sets. Another method, in some cases, is to use rubber cement for large areas and Elmer's only around the edges to insure that the paper will never totally part.

Elmer's has also served successfully for me as a sealer on balsa and other very porous woods (even on some nonporous surfaces that would not take paint unless sized first). Just dilute it a slight bit more. I'm not sure how permanent this is, but to date I've had no trouble.

On some collages I have used nothing but Elmer's. However, there is always a danger when one is gluing random printed matter and clippings from different sources that the ink used on them will run and spoil the paper. I know of no way to anticipate when this will happen except to test each piece as you go. I sometimes use acrylic medium as glue and find it works well too. The acrylic medium can be applied with a brush over *everything.* It comes in flat and gloss and dries miraculously fast. It, too, causes some printed pieces to run. It sticks for keeps, though, so there is no chance of changing your mind once it sets. When working with acrylic, keep your brush full because of its rapid drying quality. I've had great fun using acrylic medium with tissue paper, making collages by building thickness to the paper with the medium, and also by adding color to the medium. There are unending possibilities in acrylic medium; their discovery awaits your ingenuity and daring.

Over the years I have built many toy models of planes, cars, and tanks. These are made of styrene-type plastic for which a number of cements are made. The one that seems to work best for me is made by Revell. It keeps "stringing" down to a minimum. The secret to building *good* models is to prefit and sand everything until it fits perfectly. Prepaint parts (spraying, if possible) and, when you finally glue, use as little as possible. The plastic cements are very hard to remove once they get on a surface, but I have found that nail polish remover sometimes does the trick.

Also, in the world of plastics I have worked with Lucite, which should only be cemented with a liquid solvent cement. In New York on Canal St. there is a company called Amplast Inc. that supplies me with their brand called Amplast. It's applied with either an eye dropper down a seam, or with a soft paint brush. Capillary action spreads it into the seam to form a solid weld. Liquid solvent cements are more dangerous, so one must be careful about ventilation and fire. They are not for young children! Be sure to mask off your job when you use this type of liquid, as a small drop on the surface of the plastic will leave a permanent mark.

I have used some of the metal compounds, such as liquid steel, liquid solder, and liquid aluminum. I find their weakness to be their rapid drying quality, which makes them difficult to manage. They are generally too thick when taken directly from the tube, so I thin them down. Often it takes some experimenting with new products to find how best to use them to their fullest advantage.

Another excellent method of adhering paper is to dry mount it. Dry mounting, however, requires a fairly expensive piece of equipment, a flat-bedded electric iron that works like a pants presser. You sandwich a thin piece of prepared paper that has a dry adhesive on both sides between the two surfaces you wish to stick together. Then you preheat the machine. Place the three layers on the felt bed of the iron, or dry mount, pull down the top half, and let it set for the prescribed number of seconds. The heat activates the prepared paper and cooks it to both surfaces. When done with care, this does a beautiful professional job.

This method is most desirable when you must paint over the top surface and don't wish to have buckles or puckers. Dry-mount machines are mostly used by photographers to mount prints on stiff backings, but more and more artists are finding other uses for them. They're a fine investment.

So much for adhesives. Go sparingly on the amount of anything you use and remember: what slops over does no good for the job—and much less good for your temper.

Patience, friends, patience as you go.

FASHIONING MATERIALS

Here's a little bit of everything! sooner or later you'll find a use for all of it.

Think of it as a well-stocked kitchen and you'll not let yourself run short of anything.

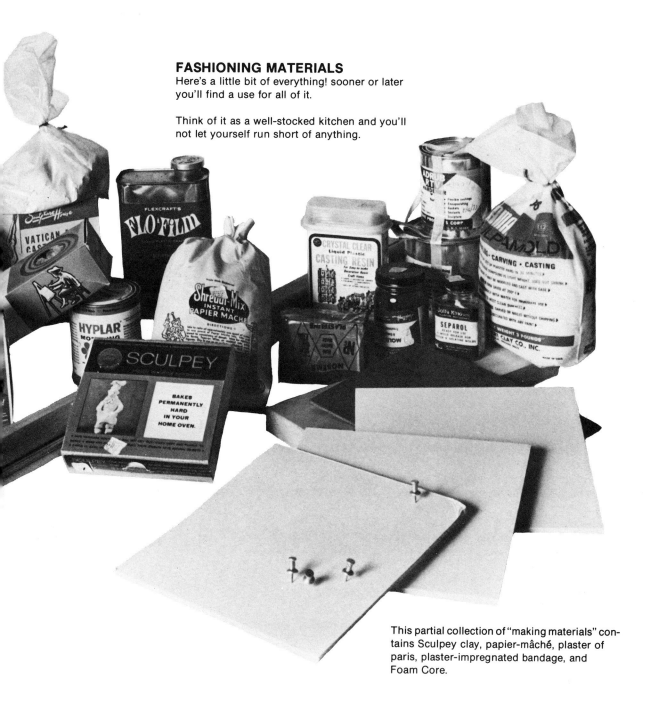

This partial collection of "making materials" contains Sculpey clay, papier-mâché, plaster of paris, plaster-impregnated bandage, and Foam Core.

FASHIONING MATERIALS

SCULPTY

This is my favorite malleable material for fashioning figures and objects. Sculpty is a doughlike plastic which stays soft indefinitely while you are working with it, but can be baked hard in twenty minutes in a kitchen oven. It takes paint very well and sands easily. It performs well if you follow instructions. It's available at most art supply stores. Miracle Clay is a similar product.

FLEX-MOLD

This latex material will enable you to make a mold or copy of any shape you desire. The mold is made by brushing successive coats of Flex-Mold on the object to be copied. When it's dry, it is lifted off and is ready for you to make

additional copies, or it can be regarded as a lightweight copy in itself. There are several clear casting resins on the market which do a great job and can be cast in almost any shape, either clear or colored. Simply pour them into a mold and let set. They assume the shape of the mold. These products allow you to imbed objects in them: butterflies, coins etc. There are many other new products such as liquid metals and all forms of plastic and synthetic compounds to be used by the artist. I try them all as they appear and keep literature and notes on them.

ARMATURES

When I work with one of the modeling products I almost always build an armature to hold the basic shape. It serves two purposes: it is the foundation and it gives the object added strength. Armatures needn't be complicated—just functional. However, if the figure is to be free-standing, it must be planned with great care so the object will be supported and its shape not be altered in the firing.

PLASTER

Plaster can be carved directly from a chunk which you can easily make yourself by wetting plaster of paris and letting it harden in a mold. The mold can be a box, a cake tin, or whatever container is the right size. To carve the plaster, use any kind of rigid blade that suits your purpose.

CLAY

Another way to achieve the same thing, but with the advantage of working with a malleable material is to first sculpt the piece in Plastaline clay, then make a flexible mold into which you can *pour* plaster.

Here's how it's done—give the finished clay piece a light coat of shellac and allow it to dry. This takes some time because the clay is an oily substance and impedes the drying time of shellac. When the shellac has dried sufficiently, place the piece on a sheet of glass and apply a coat of Flex-Mold. Make sure to add at least a one-inch lip all around the model. Never cheat on the drying period. The mold changes color (from white to yellow) and unless it is thoroughly dry it will tear when you try to remove it.

FOAM CORE

I highly recommend Foam Core. It can be cut easily and takes most kinds of paint well. It is lightweight and easy to handle, yet strong. However, it does have one disadvantage—if it is tightly pressed the surface will dent and stay dented. Treat it gently.

WOOD

Wood is probably the easiest of all materials to collect and store.

My stock ranges from new plywood of several weights, new pine, all sizes of dowel sticks and some heavier pieces up to four-by-fours. Your cellar probably contains a smattering of these already. To your collection you should start adding a stock of weathered boards, pieces of beams, and chunks of decorative woods like cedar, walnut, teak, etc.

Try to pick up discarded waste shapes like circles, cubes, etc., as well as old table legs, chair rungs, driftwood, breadboards, and similar items—the more battered the better.

Train your eye to isolate the good possibilities in a junk pile.

BALSA WOOD

Balsa wood is lightweight, easily cut, and available in a variety of sizes from slivers to four-inch-square blocks. Over the years I have learned that not all balsa wood is the same. It can vary in strength and hardness according to

the drying process used. When I select balsa, I usually make a few cuts both across and with the grain to make certain that the piece I am buying will suit my purpose. I strongly recommend selective shopping since it can vary to such a degree. Balsa wood can be carved or sculpted; however, I have found that it's too soft and fibrous to turn it into a clean carving. Avoid using it for relief carvings of any depth. I use it to form the basis of armatures, and for a lot of my building items.

BASS WOOD

Bass wood is somewhat stronger than balsa and is also very easy to work, though somewhat more expensive. It stands stress better than balsa, but, again, is not very good for clean carving. I have found that only the really hard woods are appropriate for fine carving. If you must use a soft wood, try pine. It is the best substitute and does have redeeming features: it's inexpensive, readily available, and easy to work.

OTHER WOOD PRODUCTS

Plywood, composition boards, and Masonite are all materials which I use. Each has the advantage of being fairly lightweight, with enough strength to be used both inside and outside the assemblage. They are not suitable for carving but all will take paint well when properly prepared.

MOTORS AND MOTION

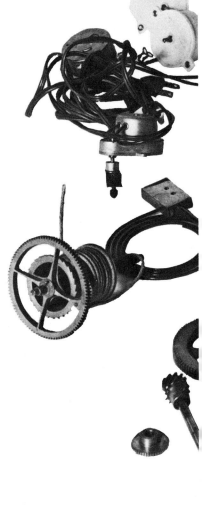

The addition of motion to your work will obviously enhance its interest immeasurably. You will be adding a bit of theater.

Some found objects just naturally lend themselves to movable ideas since their original function was to move.

My first attempt at this kind of thing was very simple. I took advantage of an antique portable roll-top home study desk. The rollers were turned by hand and revealed six feet of pasted-on memorabilia of my choice. Viewers were free to turn the knobs and view the show at their leisure.

Such simple devices soon grew too tame for me, so I plunged into a much tougher task—the W. C. Fields piece. First I made a collage of his career inside an old straw hat and mounted it on edge. Then I formed a small bust out of clay and baked and painted it. Next, I swiped an Erector set motor from my son and built linkage and gears from coat-hanger wire. When activated, the bust juggled the hat. Meantime, a concealed tape recorder in the base gave forth with one of W. C. Fields' classic monologues.

This piece was made to last only for the duration of a short exhibition, but it proved so popular and was played so much more often than I had anticipated that I returned to the gallery every second day to make repairs.

I suggest you drop in on your local electrical supply dealer and see what he carries in the way of small motors and other gadgets. Also, your local liquor or paint dealer, or other shop owner may have moving displays in his windows. These displays are activated by motors and are usually thrown out when new displays come in. They are made to do everything from one-quarter revolution per minute up to thousands, and, although they all run a complete revolution, it is quite an easy matter to make an offsetting cam.

Display motors usually cause a rocking motion or half-circle type movement, but adapting them can be part of the fun. Most of the ones I have found have been marked as to their RPM so you just have to search until you find one you can use.

There are switches now on the market that can be activated by your voice or different types of noise, and they have great possibilities for use in assemblage. For example, with noise-activated switches it would be possible to have a series of lights come on when you whistled and another set come on if you coughed. Or you could have different lights coming on as you talked because there is a switch that can distinguish the high and low sounds. The whole thing could be programmed to react to a tape recorder concealed within the piece.

MOTORS

This is a handful of motors, works, gears, and wires from my grab bag of moving parts. An engineer might slap his head in despair at my set-ups, but they seem to work for me—and I haven't blown out the lights of the city yet.

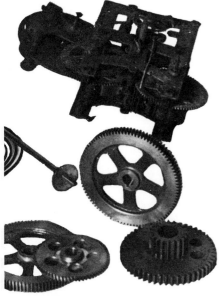

LIGHTING

Most dimensional pieces will eventually be lit either for photography or for display, so it's wise to plan for this in the beginning. The importance of lighting can't be overstressed. The combination of brilliance and deep shadow, textural highlighting, and endless nuances are a joy to the maker when the lights come on. I can't think of any other art form that can suddenly get better with the flick of a switch.

For photography I use a "form" light condition; that is, my lights are balanced so that one light (the main source) is about four times brighter than the other (which lights the shadow area). There are, of course, many exceptions to this but basically that is my first rule when shooting. If the objects were all quite light or all dark, some adjustments might have to be made, or if you want a finished product with even more contrast, the fill-in light might be left out altogether.

Most often soft edges give a better over-all feeling and softness to the art, and make it more "arty," so to speak. Hard edges usually tend to look more commercial. As to the placement of the lights, I find so much depends on the piece of art itself that no rule can be established. However, I always start out with a light higher and to the left of the piece, a ten o'clock high, and work from there. For me, this is most often the best arrangement.

The other kind of lighting you'll be dealing with is interior lighting wherein built-in lights will be an integral part of your design (such as a glow in the cab of a locomotive, or perhaps a traffic light that actually changes from red to green).

Happily, lighting equipment is available in all sizes and shapes and is becoming more sophisticated all the time.

Make sure that when everything is assembled you have access to the light so that a burned-out bulb can be changed easily.

Also, be sure to drill holes where they can't be seen so the heat can escape. If you do not, things will warp, change color, and generally deteriorate.

CATALOGS AND SUPPLIERS

Most of these suppliers offer catalogs.

TOYS, MODELS, ETC.

HAMLEYS
200–202 Regent Street
London WI, England
toy models, plastic animals and people

CORGI
Mettoy Playcraft Ltd.
Northampton, England
all forms of toy cars, trucks, etc.

DINKY
AVA International
P.O.B. 7611
6500 Depot Drive
Waco, Tex. 76710
all forms of toy cars, trucks, etc.

SINCLAIR'S AUTO MINIATURES, INC.
P.O.B. 8410
Erie, Pa. 16505
the best toy cars, tanks, and models

FEDERAL SMALLWARES CORP.
85 Fifth Avenue
New York, N.Y. 10003
doll houses, miniature furniture, etc.

POLK'S
314 Fifth Avenue
New York, N.Y. 10001
great models and miniature toys, soldiers, etc.

AUTO WORLD INC.
701 North Keysey Avenue
Scranton, Pa. 18508
complete listings of all model cars, etc.

TOOLS

X-ACTO
48–41 Van Dam Street
Long Island City, N.Y. 11101
complete line of model tools

BROOKSTONE
121 Vose Farm Road
Peterborough, N.H. 03458
hard-to-fine tools—some small, some large

MINNESOTA WOODWORKERS SUPPLY
COMPANY
Rogers, Minn. 55374
good tools, veneers, frame moldings, etc.

CRAFTOOL COMPANY
1421 West 240th Street
Harbor City, Calif. 90710
specializing in tools for all crafts—very fine
equipment

ALLCRAFT COMPANY
100 Frank Road
Hicksville, N.Y. 11801
tools for metal work, accessories for jewelry,
casting

ABBEY MATERIALS CORP.
116 West 29th Street
New York, N.Y. 10001
supplies for jewelers, castings, hobbies, etc.

H. T. HERBERT COMPANY
21–21 41st Avenue
Long Island City, N.Y. 11105
woodworking and pottery equipment, modeling
clay, etc.

ARTS AND CRAFTS

GREY OWL INDIAN CRAFT MANUFACTURING
CO.
150–02 Beaver Road
Jamaica, N.Y. 11433
everything to do with Indians

THE CRAFT SHOP
1073 Third Avenue
New York, N.Y. 10021
supplies for needlepoint, candlemaking, decou-
page, etc.

SCULPTURE HOUSE, INC.
38 East 30th Street
New York, N.Y. 10016
everything in ceramics

ADVENTURES IN CRAFTS, INC.
218 East 81st Street
New York, N.Y. 10028
prints and fancy papers, decoupage, etc.

GLORI BEAD SHOP
172 West 4th Street
New York, N.Y. 10012
beads, plain and fancy

COHEN BROTHERS
20 Eldridge Street
New York, N.Y. 10002
old watch parts

KAPLAN & GOLDMAN (No mail order)
81 Bowery
New York, N.Y. 10002
great old watches, etc.

YARN CENTER
868 Avenue of the Americas
New York, N.Y. 10001
yarn, ribbon, some unusual stuff

PICKWICK YARNS
433 Main Street
Stamford, Conn. 06901
great yarn and accessories!

A. C. PRODUCTS
422 Hudson Street
New York, N.Y. 10014
for leathers, skins, or just a belt

CINDERELLA FLOWER & FEATHER CO.
57 West 38th Street
New York, N.Y. 10018
just flowers and feathers

NATHAN ZUCKER, INC.
15 West 38th Street
New York, N.Y. 10018
flowers, feathers, etc.

PASSLOFF
28 West 38th Street
New York, N.Y. 10018
just feathers, but he's got them all

AMPLAST
359 Canal Street
New York, N.Y. 10013
everything you need for working with plastic—
just ask for Gary

BUTTONIQUE
127 West 29th Street
New York, N.Y. 10001
old buckles and buttons

CENTRAL SHIPPEE
Bloomingdale, N.J. 07403
felt

M & J TRIMMING CO.
1008 Avenue of the Americas
New York, N.Y. 10018
trims, ribbons, laces, frogs, studs, etc.

WHITLEMORE-DORGIN GLASS CO.
P.O.B. 2065 E.J.
Hanover, Mass. 02339
stained-glass equipment, etc.

SPECIALTY ITEMS
WILLIAM SPENCER
Creek Road and Conestoga Lane
Rancocas Woods, N.J. 08060
related hardware, plaques, etc.

J. C. WHITNEY & CO.
1917–19 Archer Avenue
Chicago, Ill. 60616
real car accessories, etc.

MOORE PUSH-PIN CO.
113–125 Berkley Street
Philadelphia, Pa. 19144
marking tacks, metal-head maptacks

A. LUDWIG & CO.
75 Spring Street
New York, N.Y. 10012
ornamental stampings, box hardware, and metal
specialties

TIMES SQUARE LIGHTING
318 West 47th Street
New York, N.Y. 10036
theatrical and studio supply lighting

AMERICAN PRINTING EQUIPMENT
42–25 Ninth Street
Long Island City, N.Y. 11101
wood type, brass type, foundry type

McGRAW-HILL BOOK CO.
330 West 42nd Street
New York, N.Y. 10036
catalog of instructional materials for pre-school
through grade twelve; plastic bones—skeleton
kits for cats, rabbits, etc.

SIMON'S HARDWARE
421 3rd Avenue
New York, N.Y. 10016
cabinet and furniture hardware

NEW YORK DOLL HOSPITAL
728 Lexington Avenue
New York, N.Y. 10021
doll clothes, wigs, parts, etc.

UNITED HOUSE WRECKING CORP.
328 Selleck Street
Stamford, Conn. 06902
five acres of old junk, wood, etc.

BRANDON MEMORABILIA INC.
1 West 30th Street
New York, N.Y. 10001
old cards, valentines, etc.

MILAN LAB
57 Spring Street
New York, N.Y. 10012
corks and wine accessories

CONKLIN INC.
270 Nevins Street
Brooklyn, N.Y. 11217
sheets of brass and copper

MITTEN LETTERS INC.
85 Fifth Avenue
New York, N.Y. 10016
plaster letters, stick back or pin

CORBY LEEDS
34th Street and 2nd Avenue
New York, N.Y. 10016
wooden specialty letters

HERZBERG & ROBBINS
57 West 38th Street
New York, N.Y. 10018
mannequins and parts

SCHOPFER
120 West 31st Street
New York, N.Y. 10001
taxidermist

WORLD WIDE BUTTERFLIES
OverCompton, Sherborne
Dorset, England
butterflies

BACK-DATE MATERIAL
BETTMANN ARCHIVE INC.
136 East 57th Street
New York, N.Y. 10022
engravings, woodcuts, tattoo marks, photos, all
from the past

CULVER PICTURES, INC.
660 First Avenue
New York, N.Y. 10016
old photographs

A & S BOOK COMPANY
676 8th Avenue
New York, N.Y. 10036
back-date magazines

THE NEW YORK TIMES
229 West 43rd Street
New York, N.Y. 10036
microfilms of old newspapers; photostat service
available for a fee

THE NEW YORK PUBLIC LIBRARY
42nd Street and Fifth Avenue
New York, N.Y. 10017
all back-date periodicals. Theatre Wing has
movie stills and theater programs. Photostat
service available for a fee

WOODS, VENEERS, AND LUMBER
CANAL LUMBER
18 Wooster Street
New York, N.Y. 10013
hard- and softwoods

MAXWELL LUMBER
211 West 18th Street
New York, N.Y. 10011
veneers

ALBERT CONSTANTINE & SONS
2050 Eastchester Road
Bronx, N.Y. 10461
largest selection of veneers and tools

AMERICAN MOLDING COMPANY
51 West 21st Street
New York, N.Y. 10011
all kinds of moldings

KITCHEN DECORATION

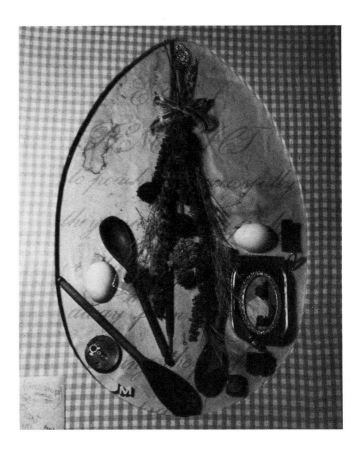

I've chosen this piece from my kitchen wall to show a theme idea.

Let me take you step by step through the construction of the original piece.

1. I started with a sheet of one-quarter-inch Foam Core board, on which I drew the egg shape in pencil. (Draw lightly so you don't poke a hole.)

Next I carefully cut out the shape with a new single-edged razor blade. It is important to make the cut in one continuous curve to avoid nicks that would spoil the graceful, flawless egg outline. Light sanding will correct any small wavers.

2. Then I placed the board over an ironed piece of checkered tablecloth material two inches larger than the board. The material was then overlapped and affixed with Elmer's glue along the four outside edges and around the egg shape. (When you work with striped material such as this, make sure that the stripe or pattern is lined up straight and at right angles.)

The problem at this point is to negotiate the curves with the material in a way that leaves no puckers. It's very simple. With a razor blade cut out pie shapes all around. The cut should stop at the same distance as the thickness of the board—in this case, one-quarter inch.

Next I glued each wedge, pulled it taut, and held it fast with a push-pin until dry.

3. The antiqued background recipe was achieved with an enlarged photostat made from a page in an old authentic cookbook. I stained it with black coffee and dried it in the oven.

4. The next step was to dry-mount it on flat cardboard. I did it imperfectly on purpose—a few controlled wrinkles added to the antique look. Dry-mount tissue and an iron were used. (See chapter on Adhesives.)

Next I glued the board with the stat to the back of the "egg" board and weighted them evenly with books until dry.

5. Now my stage was set and I was ready to dress it with my cast of props. First I selected a collection of dried herbs.

Then came the objects—all carefully cleaned and ready for mounting.

3

1

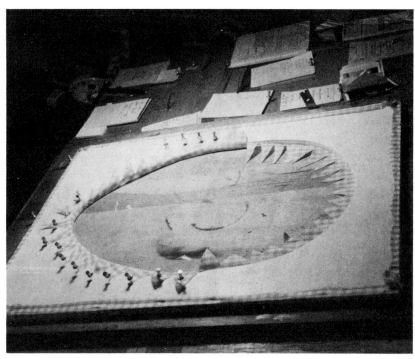

2

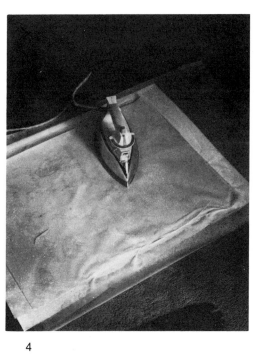

4

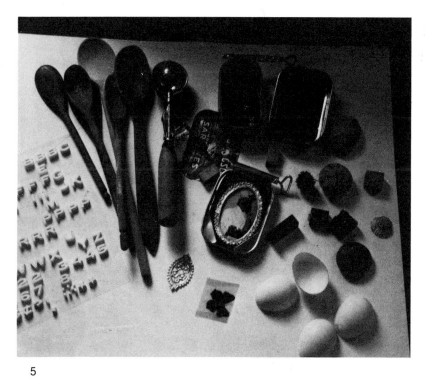

5

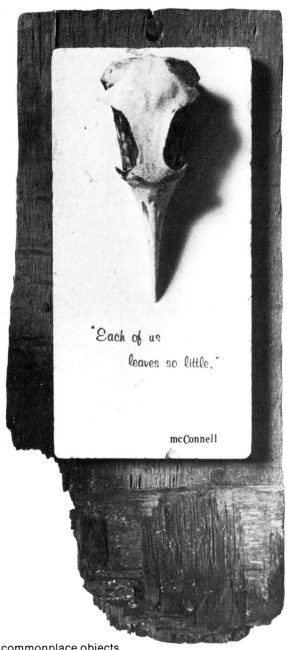

"Each of us
leaves so little."

mcConnell

OBJECTS

Here are two examples of how the simplest and most commonplace objects can take on a new life when isolated and staged in a new and sympathetic environment.

In both cases, I've used commonplace objects as symbols for literary quotations.

The bird skull was combined with cracked porcelain and a burnt board to complete the feeling of total past—all life gone.

The hardware piece combines rusted iron, weathered wood, slate, and burlap—all rugged, handsome materials in themselves and very comfortable and handsome when combined.

The hardware (part of a barn-door sliding system) is a fine example of a utilitarian object that is so beautifully designed it can stand alone as sculpture. Note how the type becomes an integral part of the whole. I urge you to consider letter forms in everything you do.

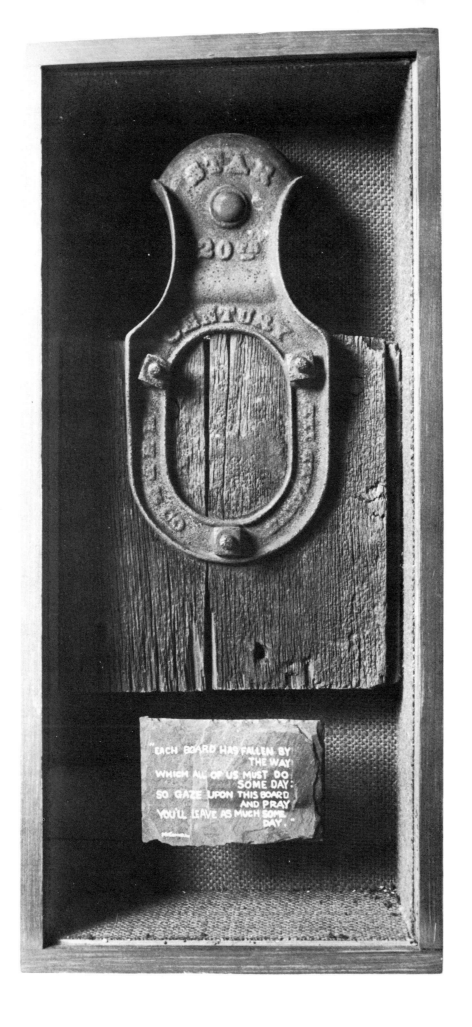

Old camp-stove door retrieved from a burned-out hunting camp

Old campaign helmet from the Spanish-American War along with some memorabilia from that war, all added to a bell jar

Often you can use things just as they come without doing a whole lot to them.

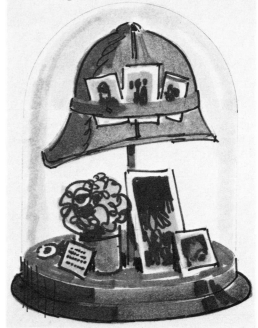

Old turned table leg screwed to weathered board

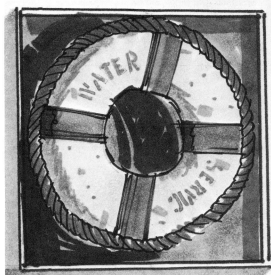

Old pressed-tin decoration used during the late 1800s on New York brownstones. This piece is so great it just needed a Lucite case to display it.

Beautiful old life preserver found by my oldest son. I just added the rope and put it into a box for display.

Tin decoration put into simple box for display

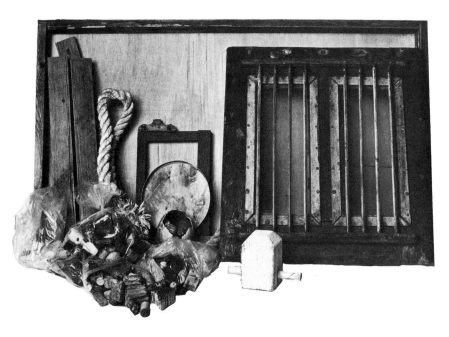

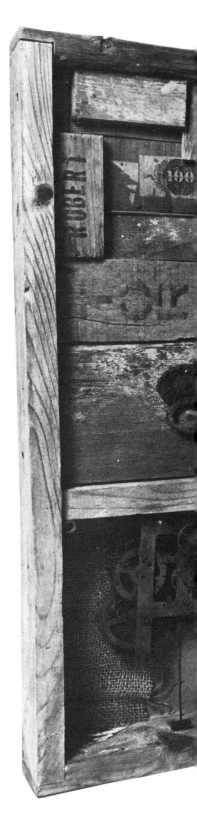

SEA

This is a pure beachcomber's piece. The sea delivered it right to my feet in separate pieces. It will do the same for you if you'll just stoop at the water's edge. This is a nice change from rummaging in dusty attics and damp cellars. You stay clean and pick up a tan to boot.

I've never had a luckier find than the beautiful sailing-ship's hatch cover in this piece. You should see the color and quality of the corroded brass!

Most people love to beachcomb, but usually they settle for shells and driftwood. That's fine, of course, but there is so much more to look for that can be converted into an artistic composition.

Such things as cork, colored glass, rope, boat parts, rusted chain, and spikes can be found. And of course there is the endless supply of bleached and worn wood of every description.

I built this frame of crude sea wood so the color would be consistent with everything else. Notice how the corners are notched—just a small refinement but the kind of touch that gives an added bit of distinction.

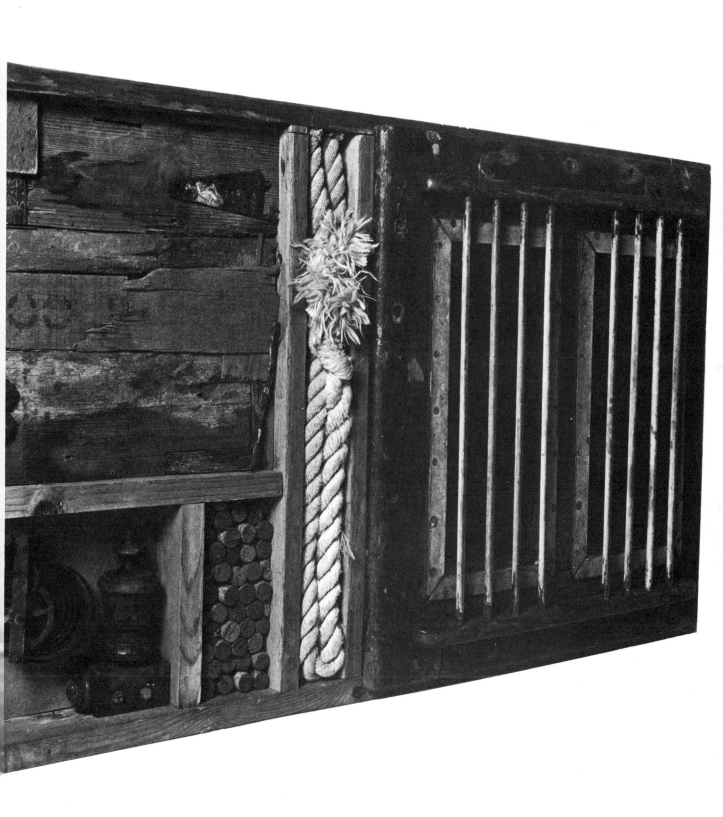

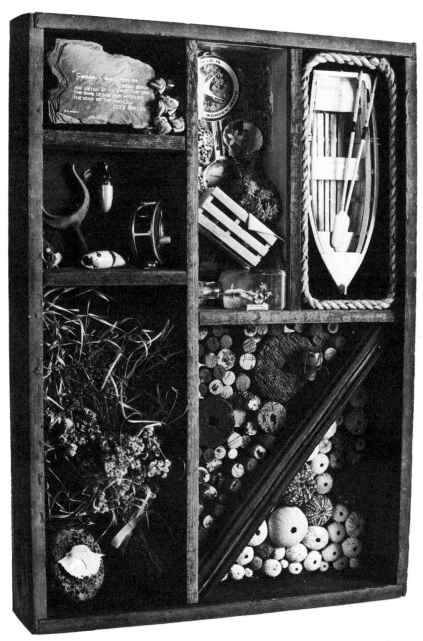

Always look for ways to make what you do distinctly yours.

This piece, as you can see, is a quite different approach. Though also nautical, it is far less pure beachcombing and more junk-shop than the other.

Most of its contents were found. The only major construction was the lifeboat, which I made from balsa strips. I really packed this piece. The pickings were so good I even had to reject some things for lack of room.

Contrast this overstuffed piece with the sparse Valentine one on page 74 and note the two extremes.

Some shells are so beautiful you just have to mount them. The nautilus has so many compartments you might want to fill each one with a different bright-colored sand, or just mount it by itself.

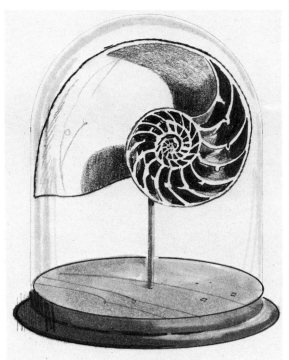

Bell jar

This assemblage is nothing but a collection of little bits of wood and rusted metal picked up in an hour's walk on the beach and glued to the side of an orange crate in about another hour. These are lots of fun for the whole family to do and they make nice decorations.

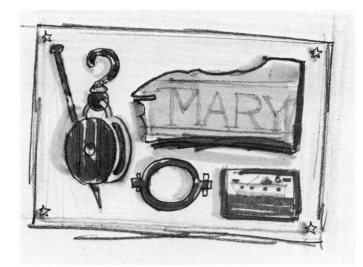

Some of the pieces of the Mary-Dee left after a storm, along with a photo of her as she used to be.

Sea urchin

If you can put a low-wattage light inside this shell, the rewards are worth the trouble.

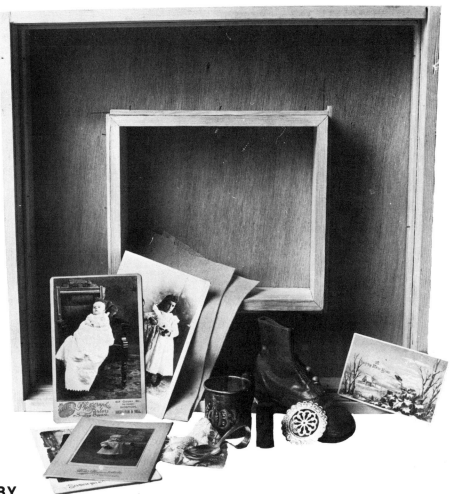

BABY

How long has it been since you last saw all of your "baby things" or those of anyone in your family?

Chances are they're separated and stuck away someplace—the photos in one place, the silver cup and spoon in another, the trinkets in yet another.

These sentimental things can give you great pleasure if brought all together. Not only do they have a real connection but from a design standpoint they meld together well. You can also get as pretty and as pink and blue as your sentiments dictate.

In this piece I built a stage within a frame and allowed the flower and lace to drape over the edge of the stage, which created a graceful look and added still another dimension. The stage is lined with deep red velvet. The mat is parchment paper.

As you can see, I trimmed the inside of the frame with a gold paper molding, which can be bought in a hobby store. It comes in many patterns and is an excellent way to hide edges and to create an additional nice touch.

Think of what you might accomplish if, for instance, you collected the silver cups of three generations—your children's, your own, and your parents'. What an intriguing assemblage that would make.

Perhaps instead of building a box you might use one you have saved—an old lunch box, a toy box, or a child's tool box.

And think of combining your mementos with toys and dolls of all kinds.

The possibilities with this subject are endless.

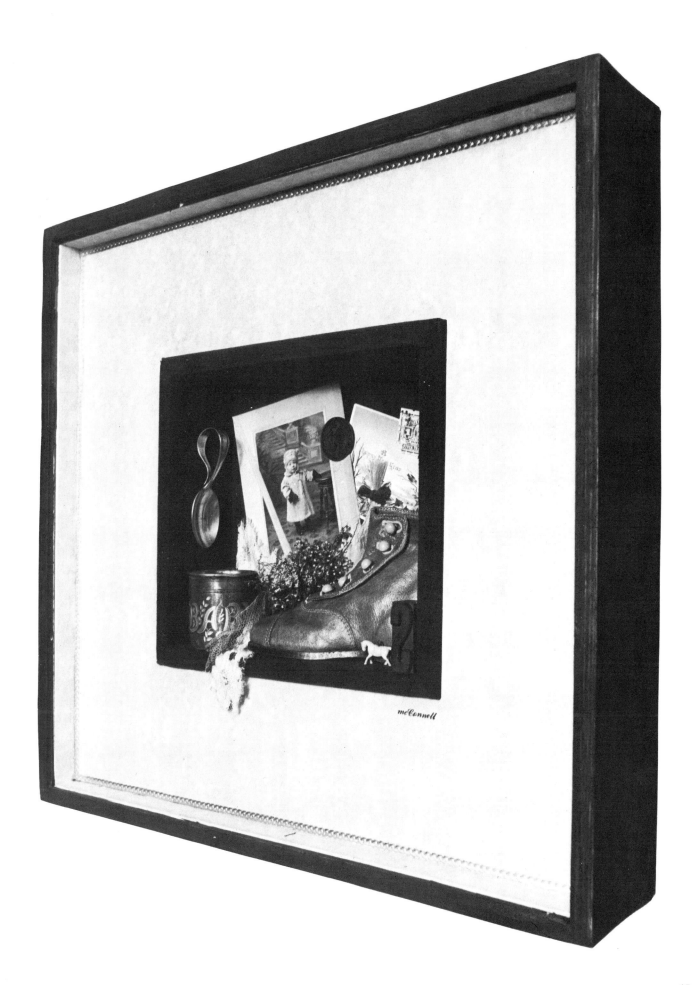

mcConnell

You could make an assemblage with some real items (like a real egg), then add a photo of the new tot to it, photograph the whole thing and have your birth announcement.

Every family winds up with loads of photos of junior from pre-school childhood through college. There's really no end to the lovely things one can do with them and how appropriate they are for most occasions. One just has to think a bit to come up with loads of new and creative ideas.

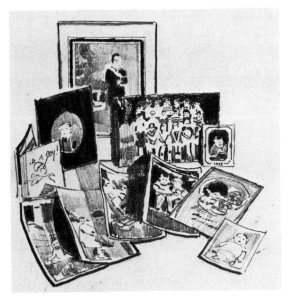

Pin or award

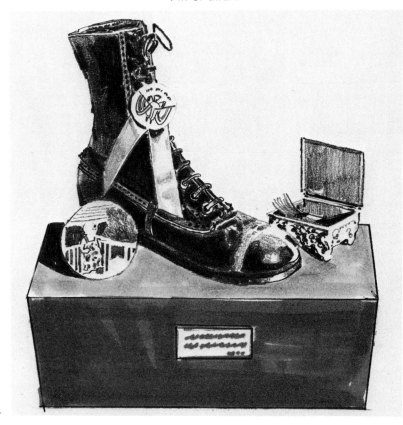

Lock of hair in little chest

Do you remember when people had baby pictures put on buttons?

All these could be glued to a block of wood with a plaque.

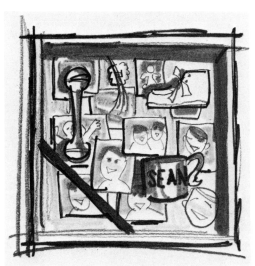

Old baby shoe

You could take some real items—baby cup, rattle, shoe—then add a whole bunch of baby snaps, a bright ribbon, etc., and there you have it.

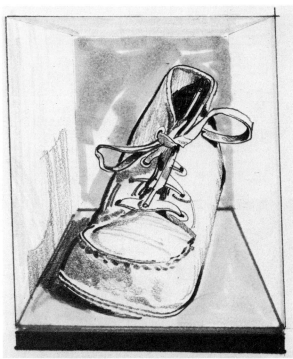

Today Lucite boxes are available in all sizes for just such occasions.

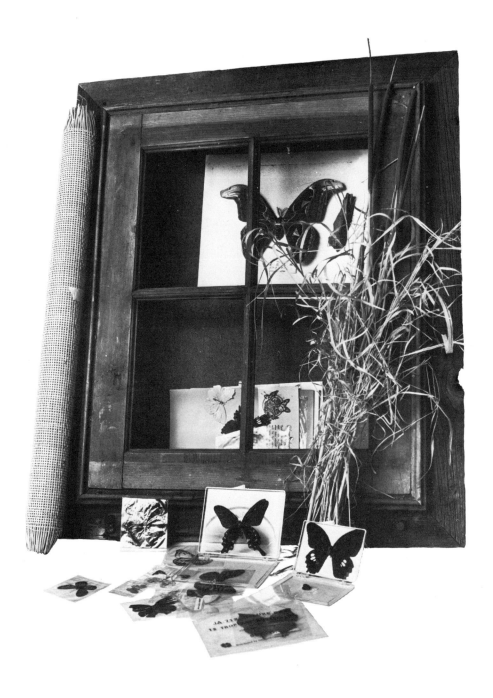

BUTTERFLY

I think it's a good guess that nature provides more material ready to be picked up and used in collage and assemblage than any other source.

In this piece I chose dried swamp grass, cat-o'-nine-tails, and butterflies to compose a simple but, I think, handsome wall piece.

The weathered window frame and cane matting make an appropriate background and container. All the materials are low in key and muted in color—a planned foil for the brilliant flashes of the butterflies.

This was a total gluing job requiring patience to affix the delicate objects to each other. Your tweezers will be handy on a similar undertaking.

I suggest you try such a piece, making use of those things in nature that appeal to you—anything from dried flowers (or artificial ones) to autumn leaves, acorns, ferns, branches, bark, etc. If you're not aware of it, artificial birds made with real feathers are available from hobby-craft stores. You can often purchase real stuffed birds from local taxidermists.

Then, too, there are interesting stuffed toy creatures. But that is only one possibility among dozens of others.

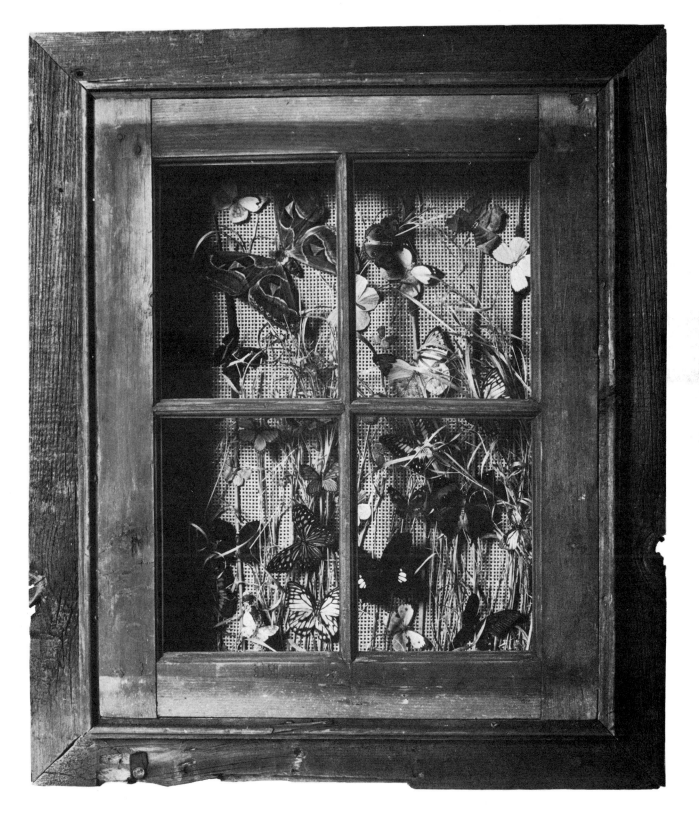

I've had good luck finding dry puff balls and some mushrooms which are great to use.

You can usually find a dried conk on a walk in the woods.

I like to use skulls for decoration and find them interesting to most people. I didn't find this bear skull but rather traded for it. However, I do find plenty of skulls of birds and small animals and an occasional deer and sometimes a turtle shell or two. They make great pieces for an assemblage.

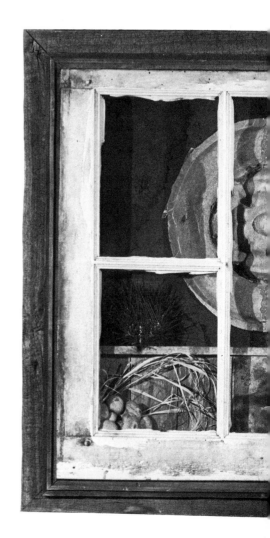

You may score the underside of conks and actually draw on them.

One assemblage for fall could have autumn leaves and an exploded cattail and some grosbeak wings on an old cheeseboard surrounded by dry grass.

Group photos from a fall camping or hunting trip

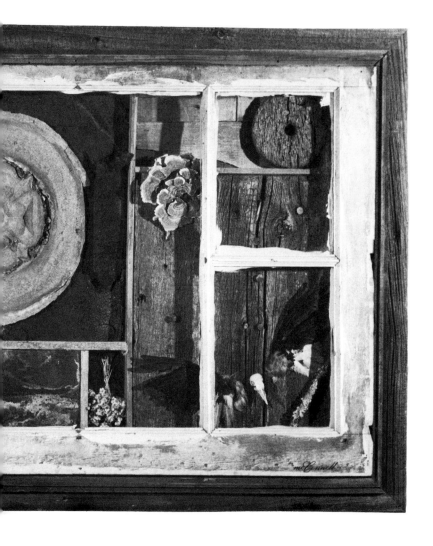

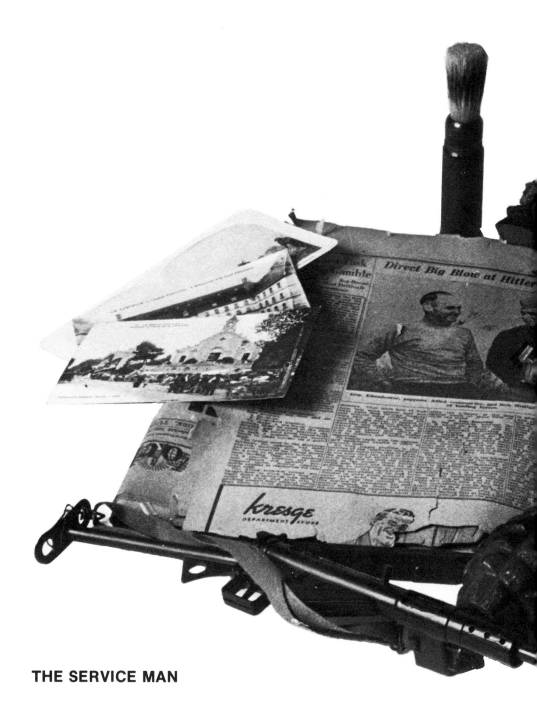

THE SERVICE MAN

If there's one experience that provides more in the way of sentimental memories and bits of memorabilia than any other, it's probably one's military service stint. Collage and assemblage provide a great way of getting all those mementos out of bureau drawers and into the open in your den, family room, bar, or office.

The two pieces I've designed are meant to whet your appetite to the possibilities of this subject matter.

Note that in the Army piece I've worked on two levels: the three-dimensional objects are glued to the back of the frame, which has been papered with period newspaper headlines. The foreground level is about two inches higher, thereby creating a "peephole" into the box. This arrangement also creates a nice shadow, which enhances the objects inside.

The outside level was done by gluing an old pair of fatigues to cardboard,

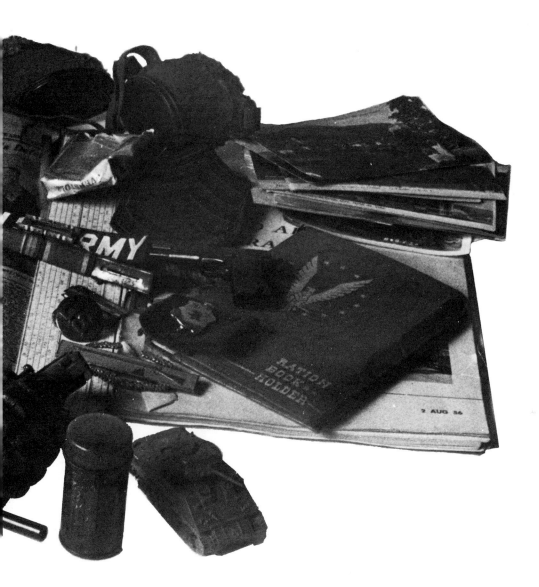

cutting out the helmet shape, and spot-gluing various insignia around.

The Navy piece is done on one level but packed with objects including some props that were not souvenirs but which helped to dramatize the idea. The Japanese parasol, the toy sailor, and the model submarine fit this category.

Incidentally, I bought that sub in 1969 for $12. After I had used it for this piece I went to the same shop to replace it. The price was now $45! I should always buy two of everything, but then I've hardly got space for one of everything.

By the way, if you don't have quite everything you need to do a military piece, between surplus stores and toy departments—and your contemporaries—you can usually fill your needs.

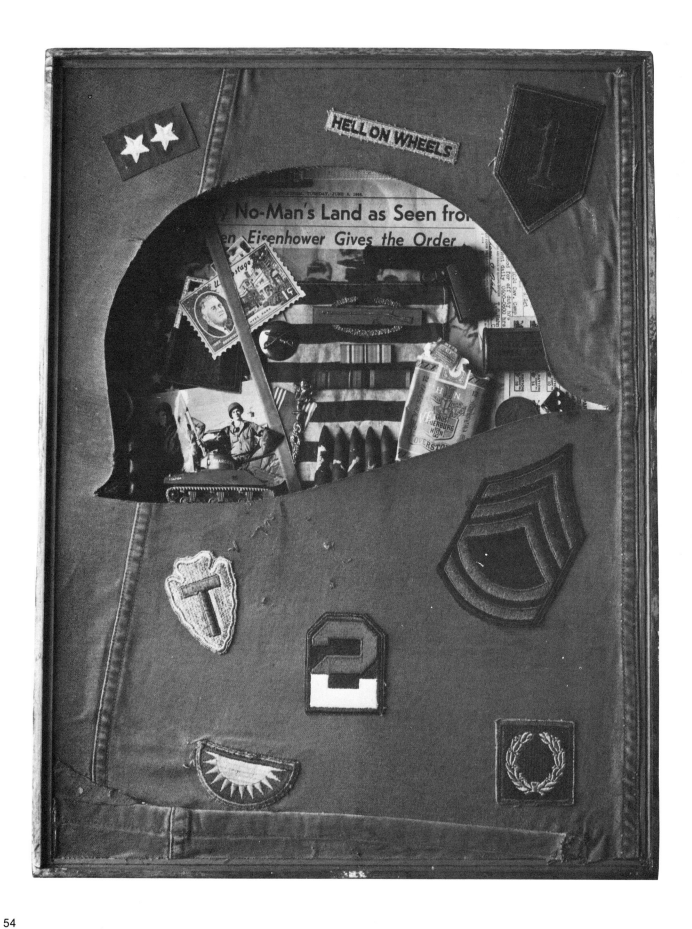

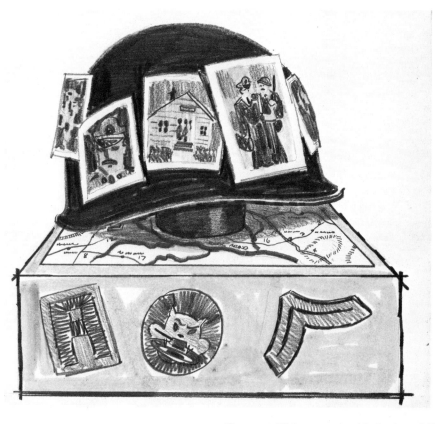

Do you still have your old steel pot? Put it atop a map of where you went, paste on some of your snaps, and add your old patches to the assemblage.

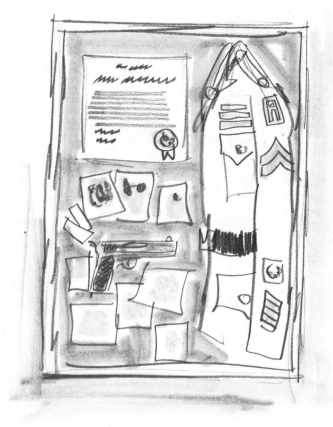

Here's what to do with that old uniform that no longer fits and the discharge papers you keep misplacing. Put them all into a big assemblage for the den.

All you need is a straight box with glass or Lucite. Be sure to fasten the jacket in several places so it can't shift once the glass is in place (a staple gun might be very handy for this one).

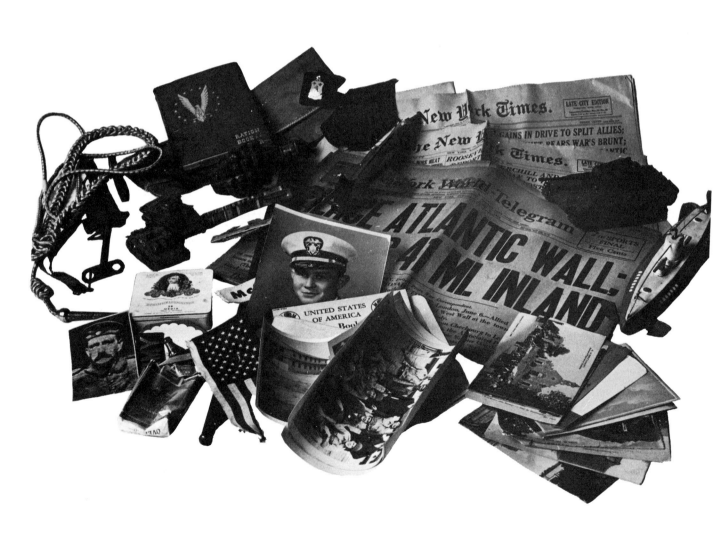

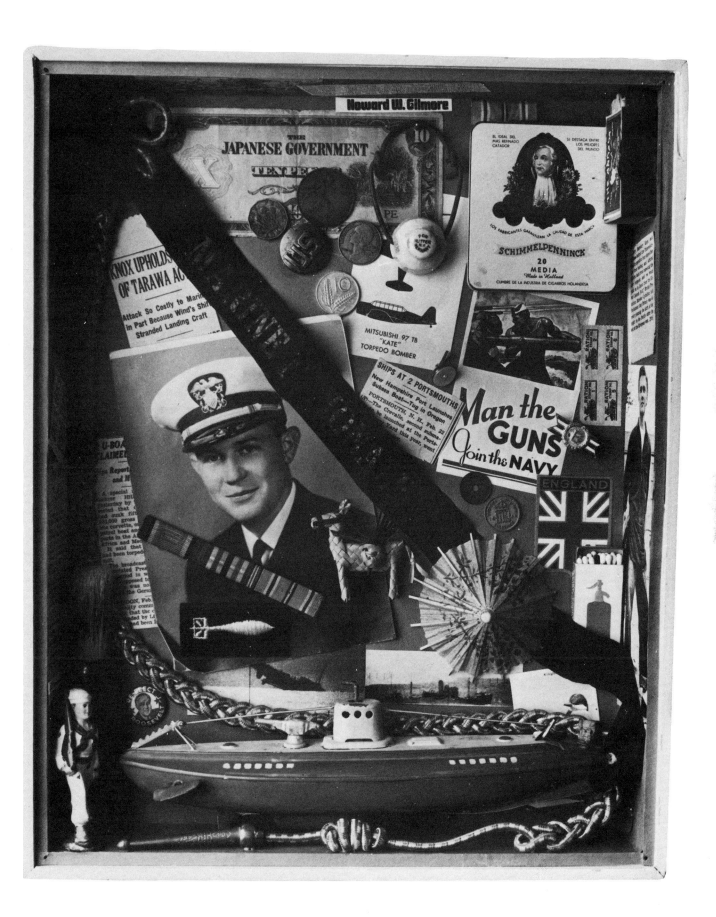

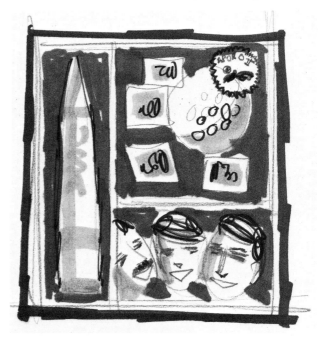

Patch from mission

Map of moon

Photos of
the astronauts

This could be a plastic box with a model missile.

There are models of missiles in almost any
scale you could want and they're great for
getting started on some space as-
semblages.

Model of LEM on top

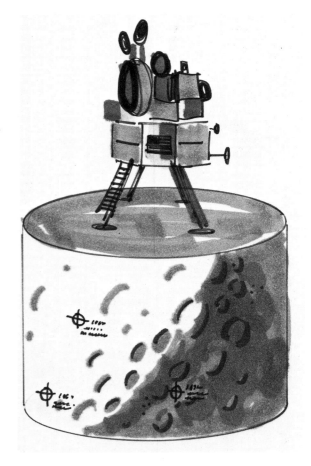

A Lucite cylinder with moon map inside,
marked for the space landings

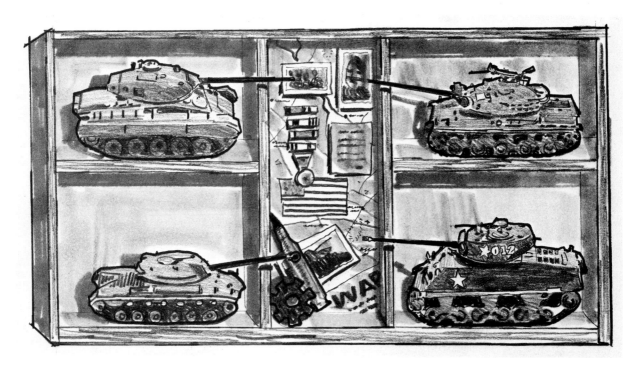

You could make these four model tanks, maybe two American and two German, and in the center you could add some battle ribbons, maps of the theater, old newspapers, and photos. Just put all of it into a simple wooden box.

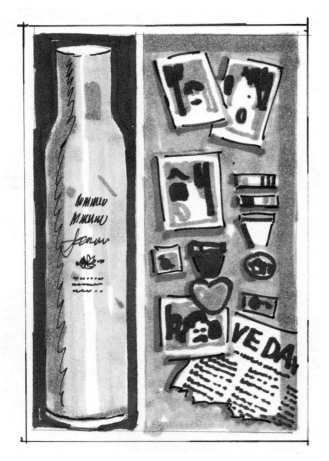

Paint wood face white and stain box side dark.

You could line this part with old burlap.

Large shell. Again you could use your Prestype to personalize the assemblage.

I usually can get medals and old battle ribbons from coin stores.

Old newspaper clipping. (You can still find lots of them around.)

CARS

An interest in automobiles is, I assume, part of the American heritage. I know I have that feeling. I was putting together car models long before I became an artist.

There's so much about cars that makes doing an assemblage for someone as a gift a natural. How about your former teen-ager who for years counted the days until he or she could get a driver's license? How about a parent or relative who had an early car that was their pride? How about your mate who had a high-school jalopy? How about good old *you*?

Happily, most people get their picture taken in or near their cars, and these photographs are a good start. Old license plates are always available. You might already have some nailed up in your garage. Then comes a myriad of other usable objects—old keys, hub caps, radiator ornaments, tools, goggles, old road maps, warrantees, AAA seals, spark plugs, and other small, recognizable parts. These, combined with the model of your choice, can make a fascinating piece. That's all I did with the sample shown here. I also lined the inside of the box with artificial pigskin and glassed it over to protect the objects. The 1910 side lamp was fastened in its own compartment and left open for people to touch.

This small contrast of closed and open creates a startling other dimension when you stand before it.

Learn to experiment in such a way before you automatically put everything behind glass—or, conversely, leave everything open.

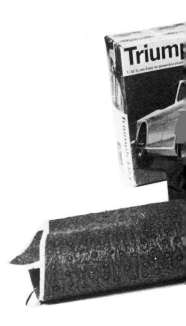

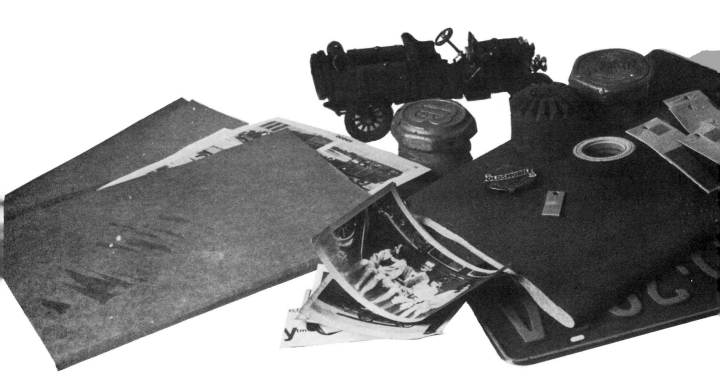

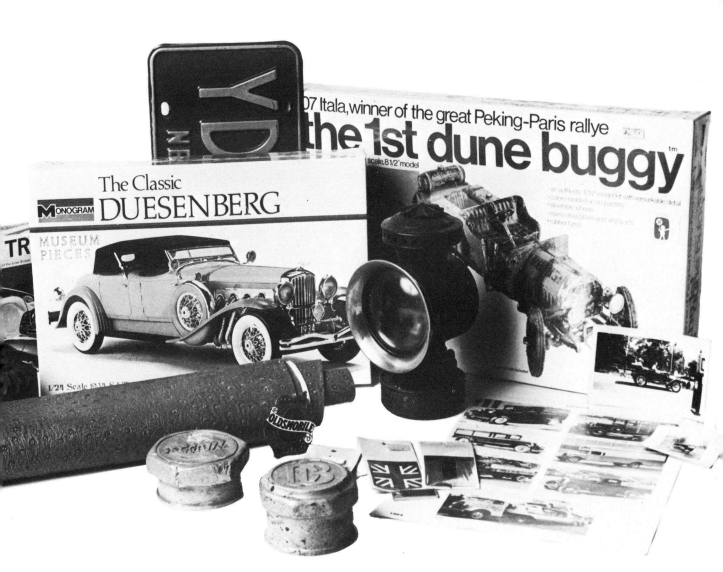

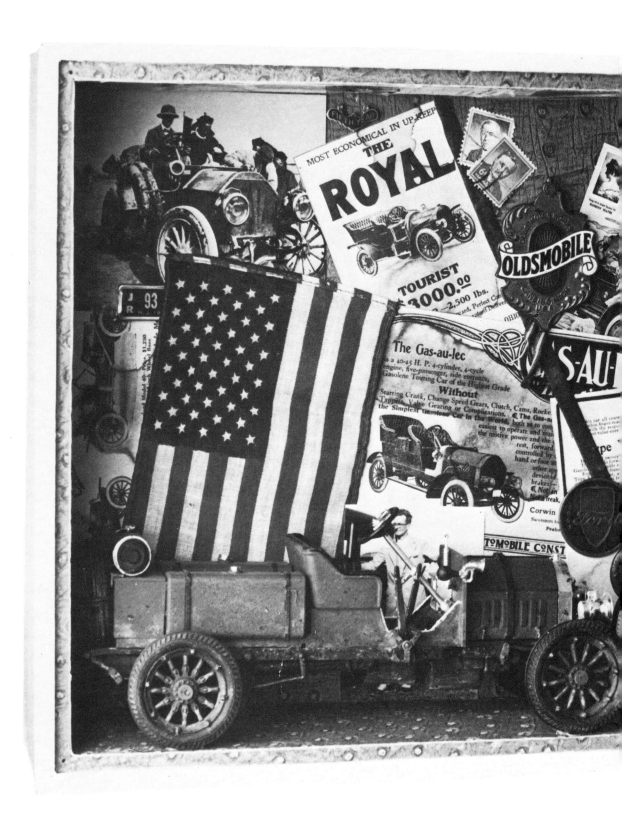

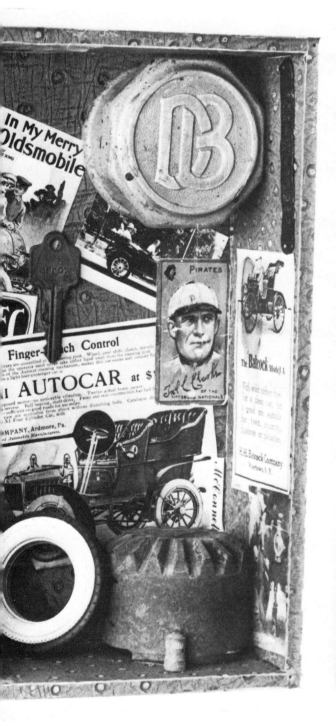

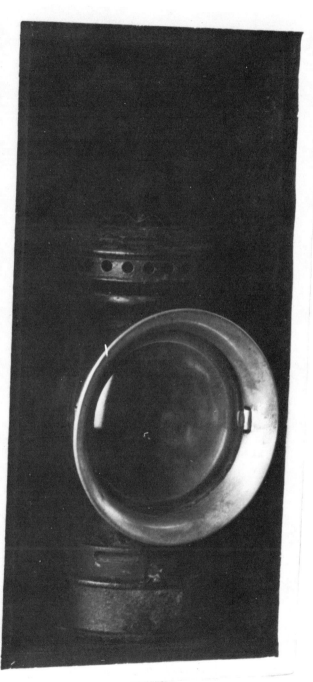

Tire hammer for wheels Old photos

Side door of 1965 Triumph Model of car

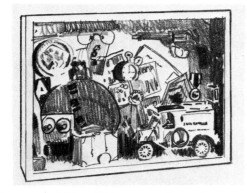

This one could be all the mementos col-
lected on a trip you took along with a model
of the truck or car you took it in.

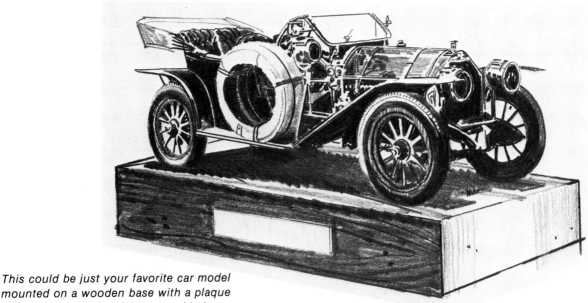

This could be just your favorite car model
mounted on a wooden base with a plaque
telling people what it is. You could also
have a plastic top to protect the model. If
the under part of the model is finished, it
would be nice to have a mirror on the base
top.

A simple assemblage using the old car lamp. Some old photos or ads, and a car model, a ribbon, some background material, and presto, you're done!

Old car hood

License plate

Steering wheel

Old photos

Hood ornaments

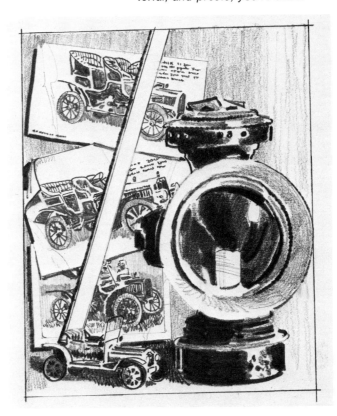

You can go to any junk yard and find lots of objects to go with a particular car or model you have in mind. Also I think you could do a good job starting with the grill from your favorite car along with the real hero . . .

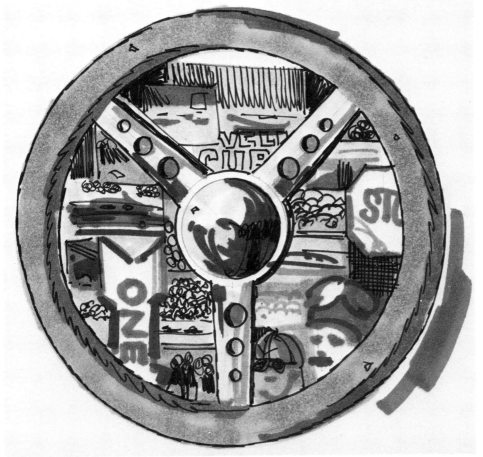

Lots of photos and scrap about racing, etc.

Postcard from races

Steering wheel

This could be used without a frame.

WINE

This is one of those happy instances where one begins with a beautiful ready-made object that just cries out to be used and enhanced. This lovely unpainted wooden box made with slotted corners, brass hinges and latches, and a simple rope handle was an imported wine gift box.

Wooden boxes are seldom used in commerce any more so when you see one, grab it. I find liquor stores are the best source.

I used the open box as a stage within a frame by stapling it to the back board, thus suspending it. The black-and-white photo gives you no clue, but the box, stained deep brown, is set against an apricot velvet background, and the outside edge of the frame is finished with shiny gold tape. It makes a rich combination.

The tape, which comes in many widths and colors including metallic, is available at art supply stores. It adheres well and lends a fine touch in the right places. It's a great way to make accurate stripes from one-eighth inch up.

The only object fashioned by hand in this piece is the grape press, which was made from balsa wood and stained. Everything else was collected. The clippings are from two excellent old books I finally located in a Greenwich Village bookstore.

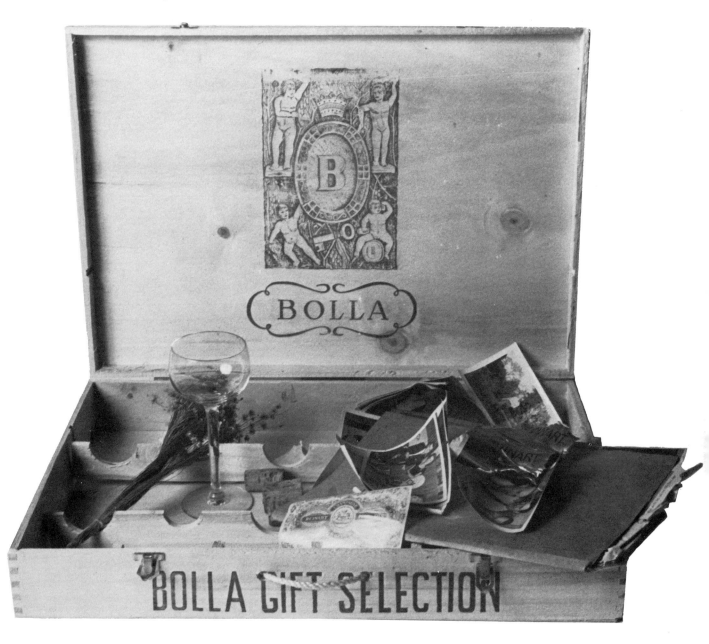

This type of bottle suggests celebration and is nice for an anniversary or an assemblage based on that theme. (Also, you can cut them down into great glasses with a bottle cutter.)

The Chianti bottle is attractive and can say a lot for you in an assemblage.

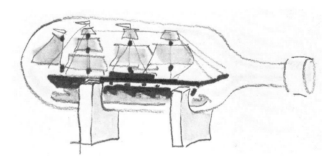

Bottle kits are commercially available. You can put whatever you like into them.

Cardboard box

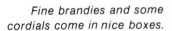

Old soft-drink-bottle box

Wine is often shipped to the United States in great wooden boxes.

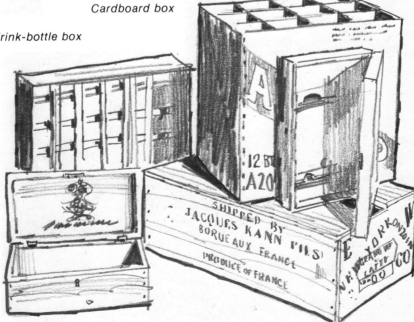

Wine splits sometimes come in small wooden boxes.

Fine brandies and some cordials come in nice boxes.

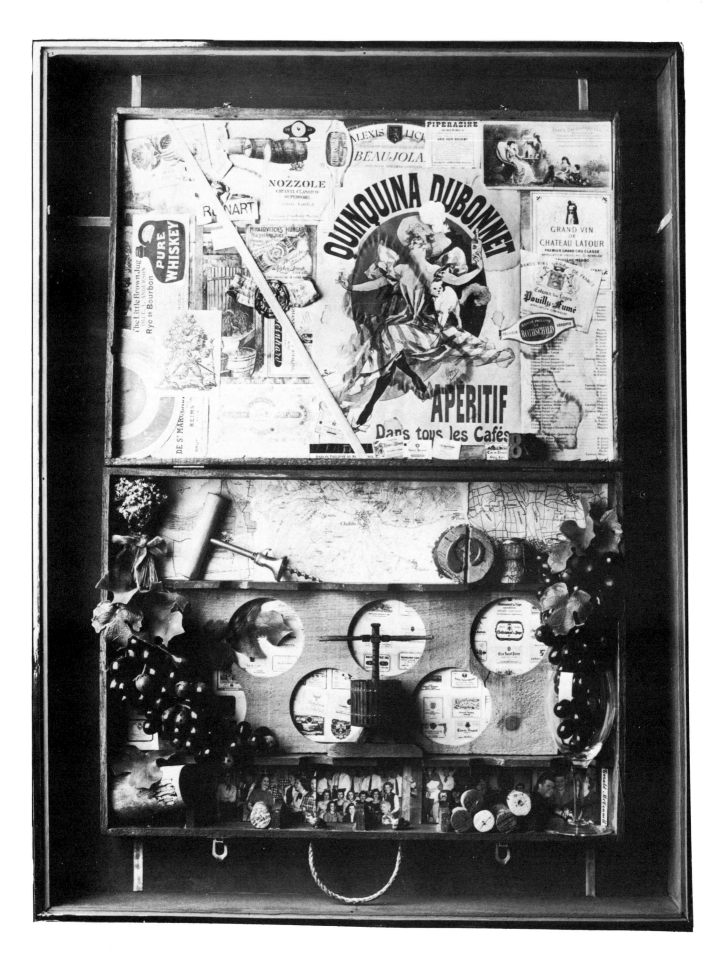

The bottle and the label make a great start for any bar assemblage.

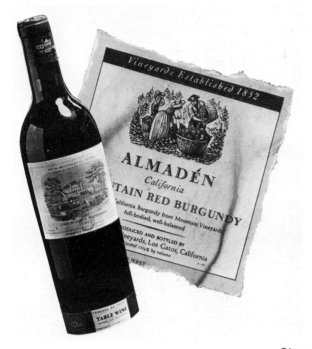

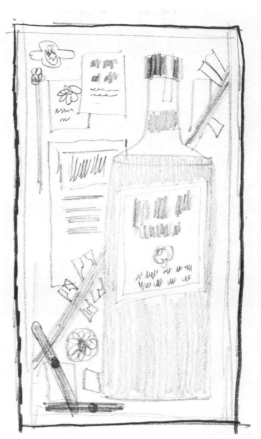

Cigars

This would be just one-half of a bottle. You can sometimes get these display items from your local liquor distributor or at your liquor store.

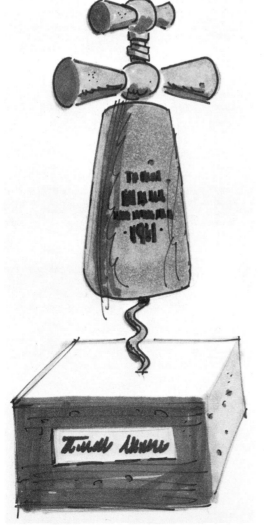

With your Prestype lettering it's easy to put a special message on this corkscrew for a special occasion.

The recipient's name

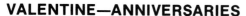

VALENTINE—ANNIVERSARIES

Annual occasions of celebration such as birthdays, Valentine's day, and wedding anniversaries offer a great chance for you to make a distinctive and original gift for someone.

It's a natural time for you to combine humor, sentiment, and private possessions that have special meaning to both you and the recipient. Such occasions provide an opportunity to make use of old examples of colored lithography such as cupids, flowers, and other rococo oddments. There will never be a better time to introduce bits of ribbon, jewelry, doilies, buttons, and bows. And, of course, old snapshots can make the piece very personal.

In the accompanying two pieces I've used ordinary rectangular snapshots in three different ways.

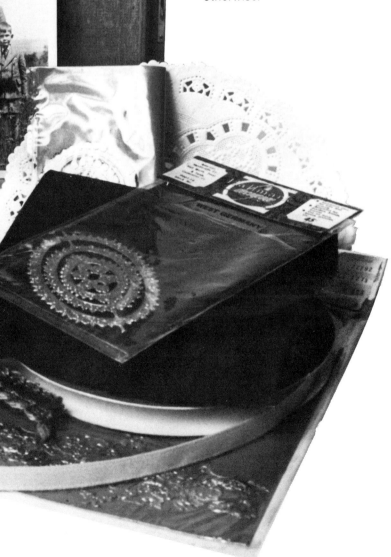

One is cut in an oval; in another the figure is silhouetted so that it stands alone, removed from the background; and in the third the heads are in a heart-shaped locket that was designed for that purpose. So you see just by that little variation three entirely different effects are created. Train yourself to seek new variations constantly.

The Valentine piece makes use of a good cedar cigar box which I first lined with red velvet, then broke up into compartments to separate the objects and create a private stage for each of them. The box is affixed to a large frame lined with coarse linen to contrast with the softness of the velvet.

I went all-out with the gold paper filigree to emphasize the feeling of gaiety and decoration. Always try to express *totally* the mood of the subject at hand.

The anniversary piece is stated much more simply. It contains only three objects, but each says so much: the numerals and the pictures in the locket tell a factual story and the addition of the small bouquet is not only a pretty, soft touch but has implications that bring the other two objects to life.

I started with an inexpensive unpainted stock frame. The oval opening was cut of thin plywood and covered with a glossy enameled paper. The objects are mounted on a backboard of black felt. The frame is spray-painted black. There is no glass in front.

Sometimes a glass or plastic front will seem right or necessary to you. At other times your assemblage just will not seem to call for it.

As always, follow your whim unless there's a very practical reason for doing otherwise.

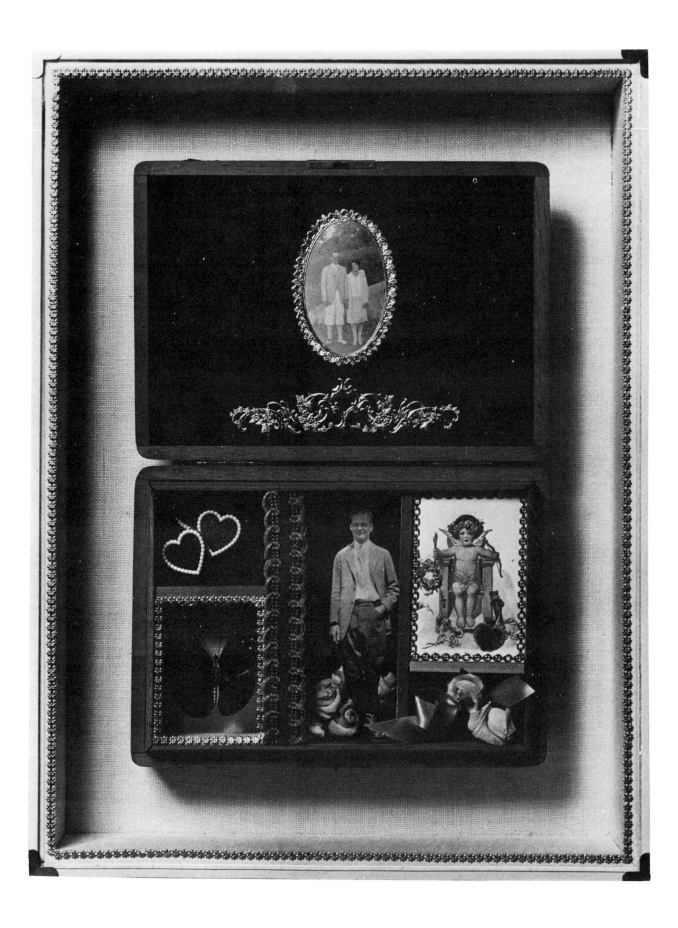

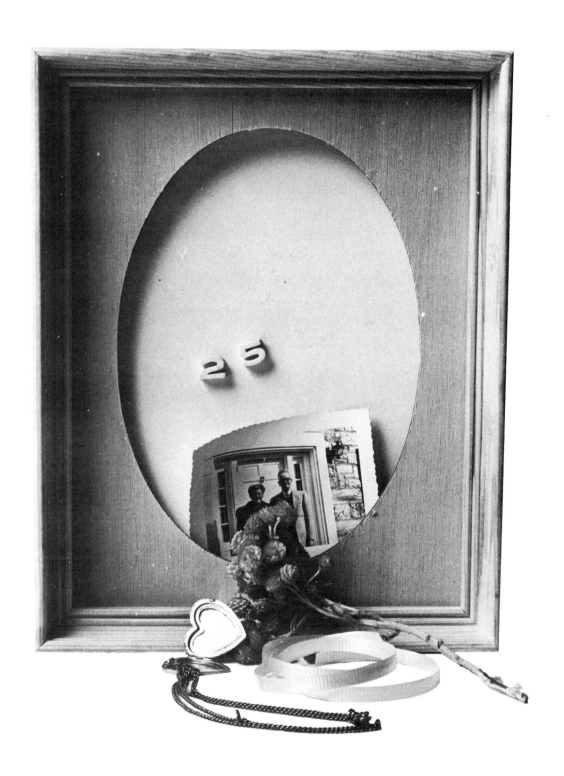

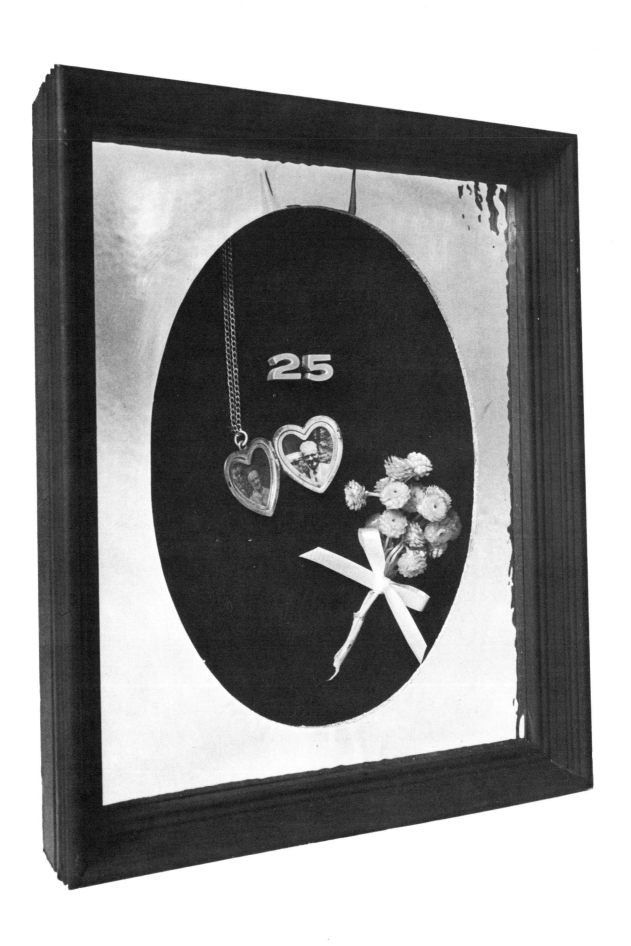

Heart-shaped cookie cutter

You can glue these two together.

Your sentiments and recipient's name,
on aged copper

You could use some red-checkered material.

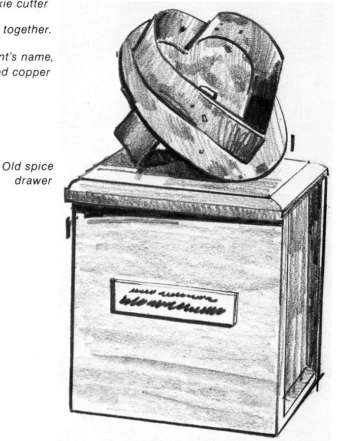

Old spice
drawer

Turn an oval into a heart shape.

The top from a wedding cake. (This can be
purchased without the cake.)

Nice photo of the birthday girl

Make the background a red velvet.

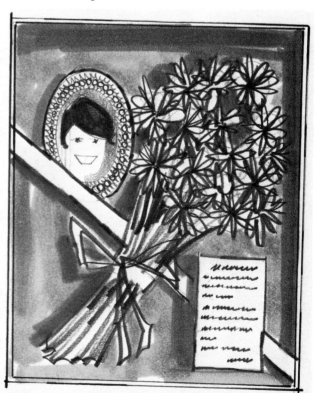

Dried
flowers

Bell jar

Your message or poem

This assemblage could have a display motor inside to make the
top rotate slowly, with your greetings written around the side.

Railroad lore may not be for everyone, but for those who are interested, look out! There are no greater zealots.

It happens to be one of my interests and is one of the easiest to follow since so much material from so many periods exists in abundance. This material includes excellent scale toys and models and manageably sized mementos and artifacts.

TRAINS

Everything I've used here was already in my possession. As a matter of fact, I had so much I had to choose. And anything I might have wanted is readily available in antique establishments which specialize in this subject.

As you can see, I have mounted objects in a rugged box (there's nothing dainty about railroading). Then I "wall-papered" it with printed pieces. The mood was set. Now it was a matter of "peopling" my stage.

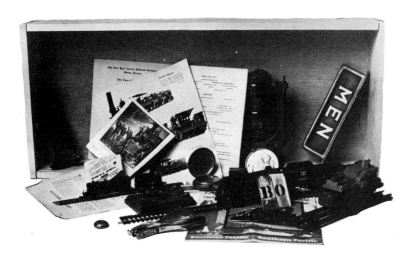

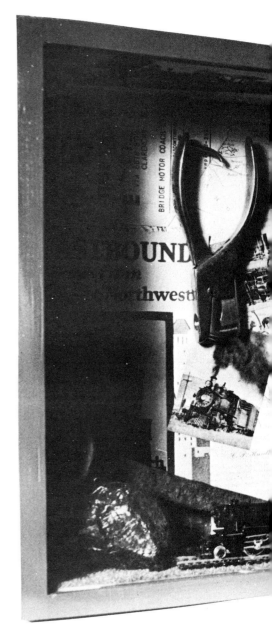

In a case like this, you should experiment. Move things around. Try different arrangements. Make sure you balance objects by their visual bulk and weight. Also balance color and interest. Remember, you are really composing a picture. When everything seems to click into place, that's it. Time to batten down and fasten. There are no mysteries here. Everything is either glued, screwed, nailed, or fastened by wire or hooks.

Since this is meant to be hung, it doesn't matter what comes through on the back wall. This makes it easy to do a strong, sturdy job.

By the way, that chunk of coal on the left was acquired long ago when my son needed a piece for a school project. We trod the tracks a long way along the Lackawanna to find a piece that suited him. That was in 1968—and see how handy it finally became.

If the energy crisis continues I may one day have to reach in for it.

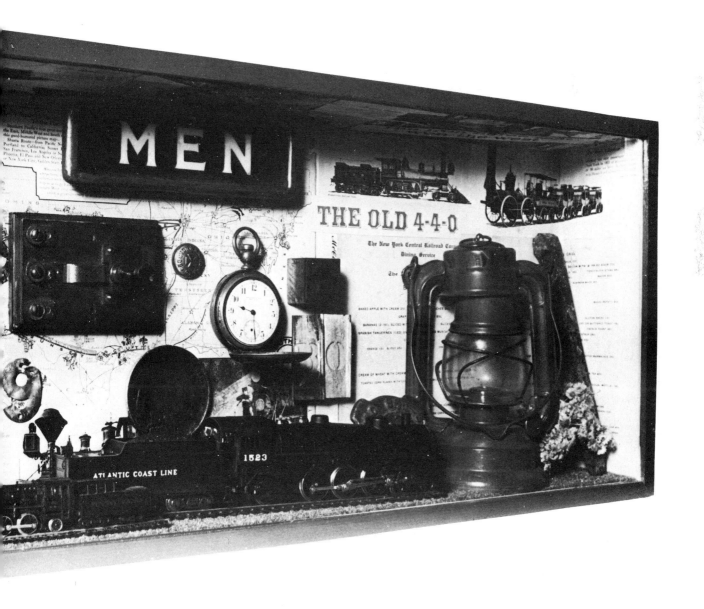

Frame could be just an old wooden box

Paste some scrap around lampshade, or paint it!

Railroad button

Railroad map

R.R. spikes

Passenger tickets

Telegraph key

Conductor's punch

Old lantern

Old oil can used on the early steam engines

I would love to be able to use the side of an old boxcar.

Scraps pasted on inside of old lantern

Add a few R.R. stencils—they give authenticity.

This could be put on a base or made into a lamp for the den.

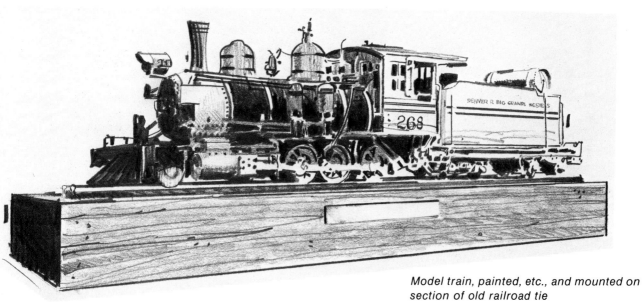

Model train, painted, etc., and mounted on section of old railroad tie

If you could get one of those old trunks, you could fill it with all kinds of great stuff.

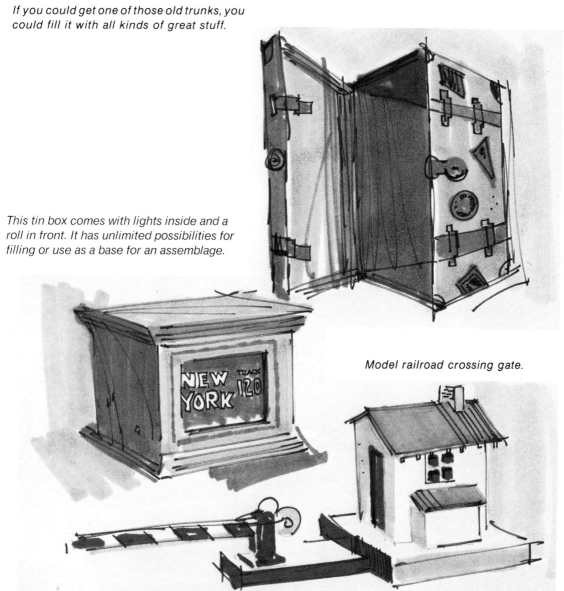

This tin box comes with lights inside and a roll in front. It has unlimited possibilities for filling or use as a base for an assemblage.

Model railroad crossing gate.

DIPLOMAS

Just about everybody possesses a diploma of some sort—high school, camp, college, military service, fraternal organization, club, etc.

Most of us have more than one, and we either settle for putting them in a stock black frame, or we file them away some place only to be seen again when we chance upon them. That's a great pity, because commemorative diplomas and plaques most often represent pleasurable moments in our lives, moments of achievement and honor.

You can revive your interest in diplomas and greatly enhance their appearance by using them as the central theme in a nostalgic collage or assemblage.

The one I've done here started with a typical college diploma from the University of Pittsburgh. I combined it with many mementos my sister had saved from her college days in the forties, plus some trinkets from my own collection.

Many other variations would have been possible: the objects could have been affixed above the diploma or around all four sides. One could use a clear plastic box or an ornate rococo picture frame instead of the plain molding I chose.

Think of the great possibilities for dressing up professional offices— doctors', dentists', lawyers', veterinarians', engineers', C.P.A.s', police chiefs', etc. It makes my juices run to ruminate on all the exciting props germane to these professions.

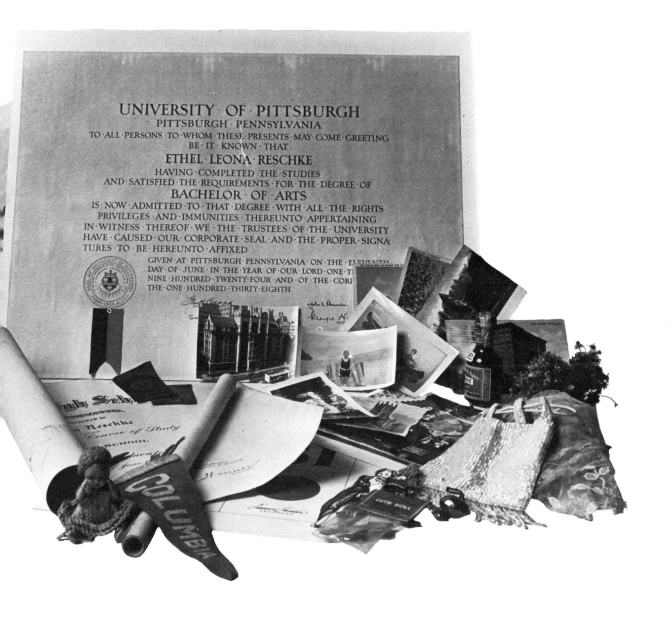

Plaques and other fraternal items will always make a nice assemblage.

A glass-top coffee table is also a good place for that diploma and the rest of your college memorabilia.

Round Lucite base with diploma fixed inside, with school colors top and bottom. Shade could be some old pennants and stickers.

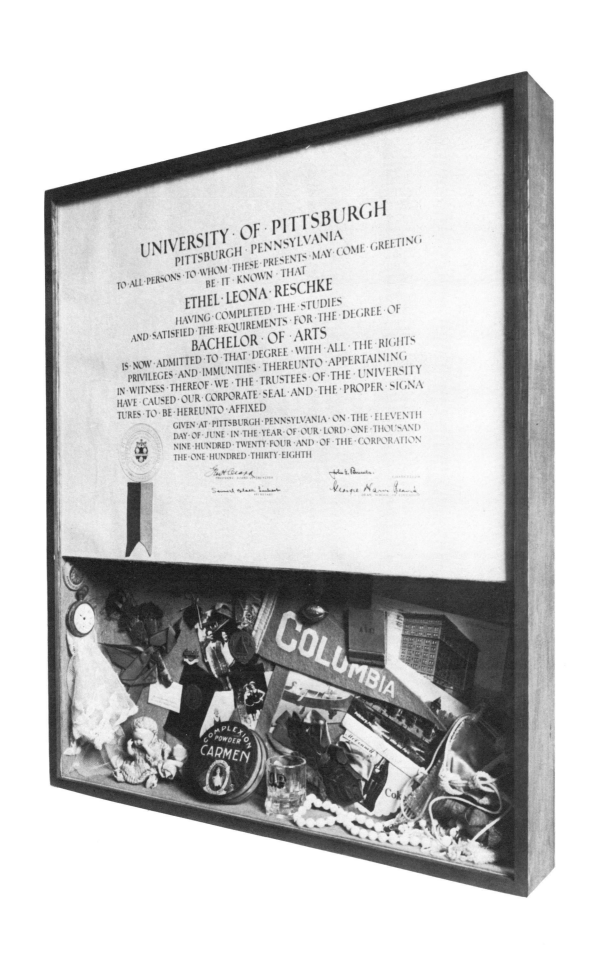

FRATERNAL ORGANIZATIONS

Americans are the most "joining" people on earth. I wouldn't begin to know the psychological reasons for this—but I am aware of one of the tangible results: a wealth of badges, buttons, sashes, headgear, robes, flags, banners, signs, jewelry, gavels, medals, and many other wild and colorful symbols and evidences of particular brotherhoods.

I love the stuff just for its look and graphic possibilities and I constantly acquire it. The pieces shown here are just a small part of my large (Lodge) collection.

I made the set-up in the bell jar to show you how well these trinkets and bits of costume lend themselves to assemblage ideas.

Think what a unique way this would be to honor someone who belonged to such an organization. It makes especially good retirement or promotion awards. If, for instance, you wished to construct a commemorative piece for a member of the Elks Club but didn't have all the material you needed, other members could acquire it for you, or the local officers could help. Often fraternal organizations have gift shops where regulation regalia is sold. Or, the person to be honored may already have the necessary items put away in a drawer. This is a fine way to get those prized pieces out in the open to be displayed in a place where they can be seen and shared.

One particularly nice feature of this material is that most of it comes equipped with pins or fasteners of some kind. It makes it very convenient to attach. Your friends will be very grateful for the gift of a piece in this category—they might even give you their secret handshake.

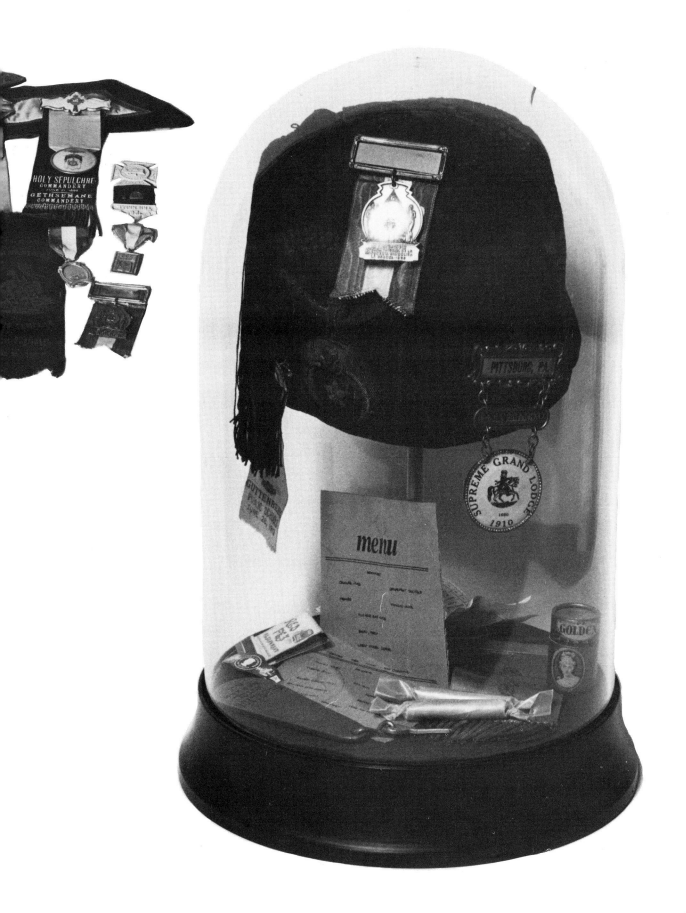

BOOKSHELVES

The next three pieces are variations on a theme. They differ from the preceding examples in that they are built into an existing set of bookshelves in my studio. (Incidentally, the ecclesiastical decoration above is part of the permanent construction. In New York you can find even church parts discarded with the sidewalk trash.) The same idea can be applied to room dividers, movable shelf modules, or shelves that you design and install yourself.

You simply use a section of a shelf as a stage in which you affix an assemblage right to the back and sides. If you don't wish to mar the wood, you can construct a well-fitting box and slide it in place. The effect will be the same. The box can be painted, papered, or left unfinished if you prefer wood grain.

If your shelf arrangement is extensive enough you can accommodate more than one assemblage, separated either by books or small pieces of sculpture, or perhaps you deal in a certain kind of collection—paperweights, pug dogs, iron trivets, or whatever.

All these possibilities are a great way of transforming an ordinary bookcase into something uniquely personal and as creative as you can get.

Also, you can "change your show" as often as you please.

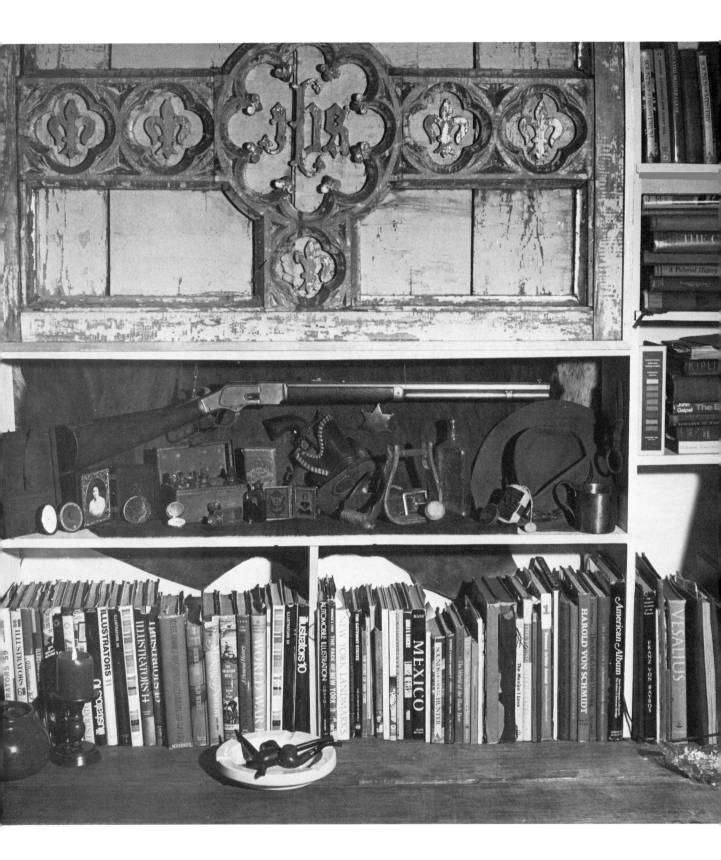

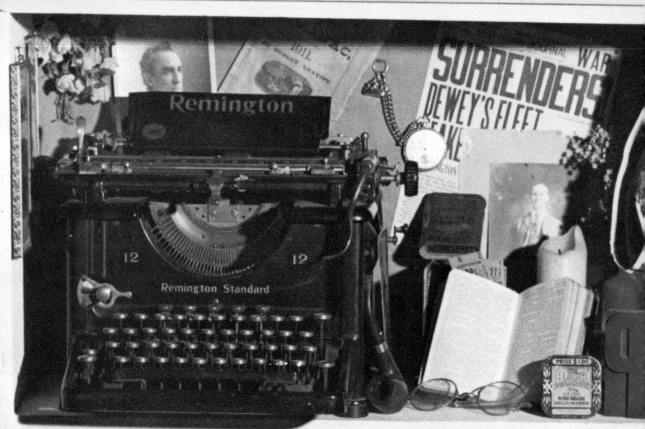

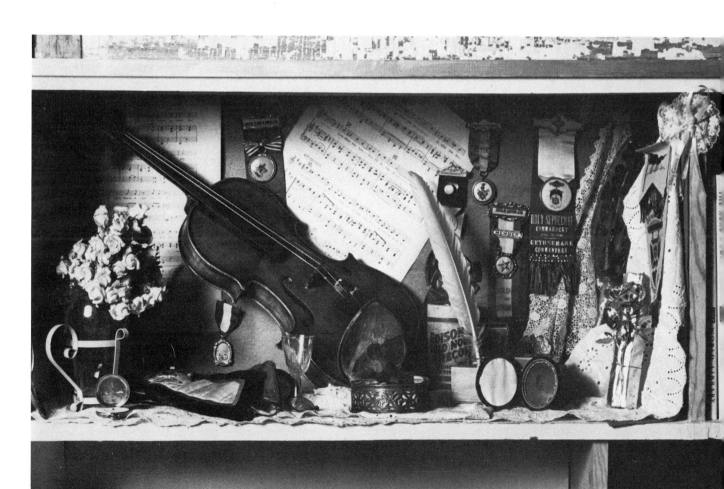

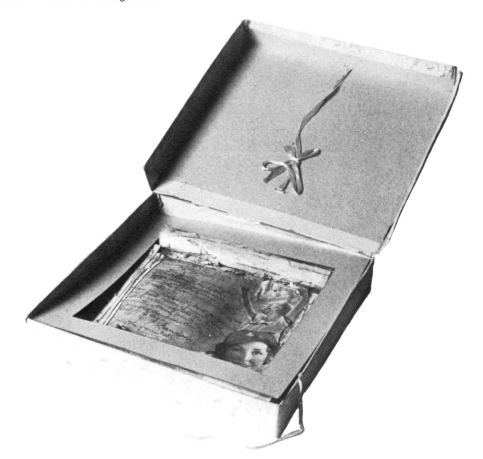

GRANDPA

This is one of the few pieces in this book that I *didn't* make, but it has great significance for me. I've only recently learned of its existence, and the discovery has jarred me.

It was made by my grandfather back in 1933 for my sister's birthday. My grandfather was not an artist, but I've learned that he delighted in doing things like this for friends and relatives.

The remarkable thing to me is that such work was not seen outside professional art circles in those days, so it's safe to assume that Grandfather must have conceived this method of expression by instinct.

He started with the simple pink box that contained baby clothes. Within this, he made a very personal collage of pictures cut from magazines and pasted on a sheet of real birch bark which he stripped directly from a tree in the Adirondack mountains where he lived. Upon this he wrote his sentiments, which begin, "To My Little American Rosebud," and end, "Granddaddy, from the frozen North."

My sister treasured it for all the obvious reasons—and I do, too, but with an extra eerie awareness of the mysterious jumping of genes from generation to generation.

To preserve the piece I've put it under glass and added my Grandfather's photo. At last he's getting a bit of deserved recognition.

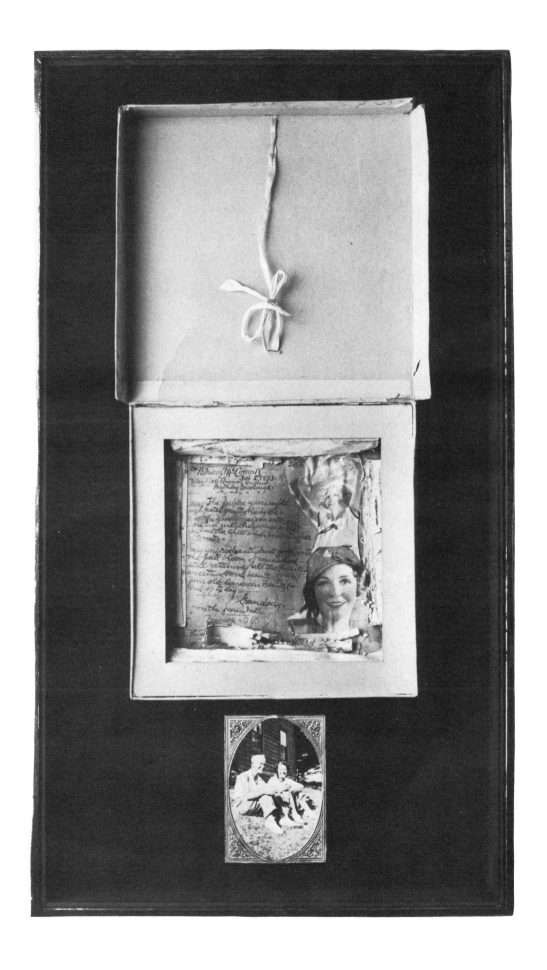

CAROLYN VAN DUYN

Carolyn conceived her assemblage almost entirely in wood. The many varieties allowed her to make use of several of the textures, patterns, colors, and directions of grain that wood offers. The piece deals more with abstract pattern than with sentimental, found objects.

She had to make everything specifically for the project except the woodcut portrait in the upper left corner; she'd made that before she started the box. Note the smart use of stenciled type above the portrait. Carolyn put it in upside down to give the graphic effect she wanted without disturbing the viewer by trying to read a literal meaning into it. I also like her sudden use of the rusty nails in the lower left. They give excellent relief to the total wooden environment and act as directional arrows to keep the eye moving around the composition. The small circular spool, right center, is also a good touch. Its shape and placement are needed; she obviously felt so too.

STUDENTS' WORK

While this book was in preparation, my work was part of a five-man exhibition of constructionists held at the General Electric Gallery, a splendid feature of the vast new General Electric Corporate Headquarters in Fairfield, Connecticut.

It seemed appropriate for this book to have several talented high school art students view the show with their instructor, and then, with no further controls except for discussion and counseling when they wanted it, plunge in and do their own assemblages.

Mr. James Wheeler, an art instructor at Staples High School in nearby Westport, picked five outstanding seniors from his class: Dianne Pressler, Judy Aley, Dennis Dale, Margaret Grenier, and Carolyn Van Duyn.

I was very heartened to see the results; first, because nothing was copied from the professionals' work. Secondly, because each piece stemmed from something very personal in each person's background and interest, it became an extension of trends and promises each had shown in his earlier class efforts in other media. The other fact that pleased me was that Jim Wheeler, their instructor, was pleased. (See excerpt from Jim Wheeler's letter, reproduced below.)

This project is a very happy note on which to conclude this book. The students are all off to college now, and I hope their brief fling with assemblage has planted a seed that will blossom later.

And I hope too that these pages will be the start of many productive and rewarding hours for you.

"The five students were members of my advanced sculpture class and so we discussed the sculptural possibilities of these constructions. We found that by studying Rodin's Gates of Hell, *in theory, it would be possible to do the boxes as pieces of relief sculpture. (Since much of my philosophy comes from Rodin, I wasn't surprised to find him literally included in several of the boxes.)*

After the initial discussion, the students were on their own. So it was exciting to see their ideas manifested when they began to bring them in. As a matter of fact, I was so pleased with the results that I have decided to use the idea of the construction as relief sculpture as a means of logically going from drawing to sculpture for all my sculpture classes this year."

James Wheeler

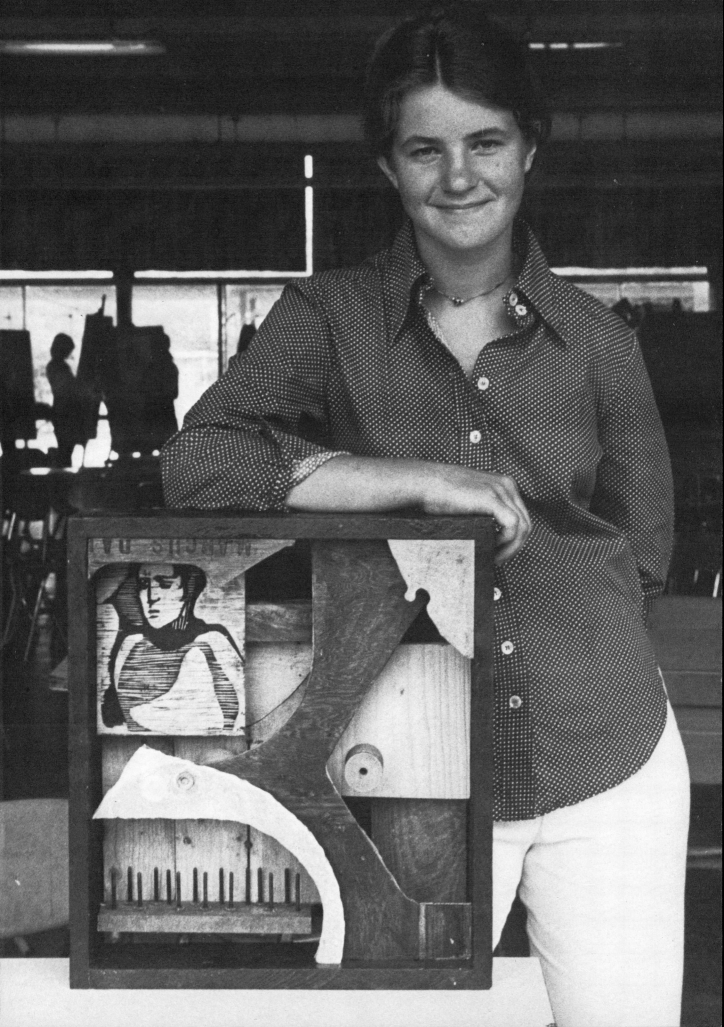

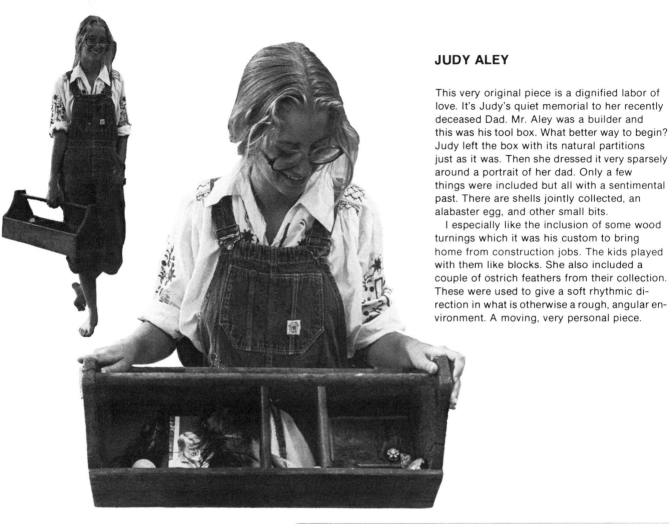

JUDY ALEY

This very original piece is a dignified labor of love. It's Judy's quiet memorial to her recently deceased Dad. Mr. Aley was a builder and this was his tool box. What better way to begin? Judy left the box with its natural partitions just as it was. Then she dressed it very sparsely around a portrait of her dad. Only a few things were included but all with a sentimental past. There are shells jointly collected, an alabaster egg, and other small bits.

I especially like the inclusion of some wood turnings which it was his custom to bring home from construction jobs. The kids played with them like blocks. She also included a couple of ostrich feathers from their collection. These were used to give a soft rhythmic direction in what is otherwise a rough, angular environment. A moving, very personal piece.

MARGRET GRENIER

Margret's idea is a charming simple one—she has portrayed the past, the present, and the future.

She started smartly by taking a sturdy bureau drawer for her framed stage and then gave equal billing to the three time periods. The left compartment has a background of dark blue material while the wood of the drawer provides the background for the other two. The contrast is good.

The left section is devoted to the past. The artifacts—crushed rose, postcard, shell fragment, and button—all have to do with adults in her family background. The center section reflects Margret's current interest—art and the dance, which are represented by reproductions. (Note how the ballet print is set forward of the background.) The last panel is accomplished by the use of futurist modules of wood. They have no literal meaning but say "future" simply and quickly.

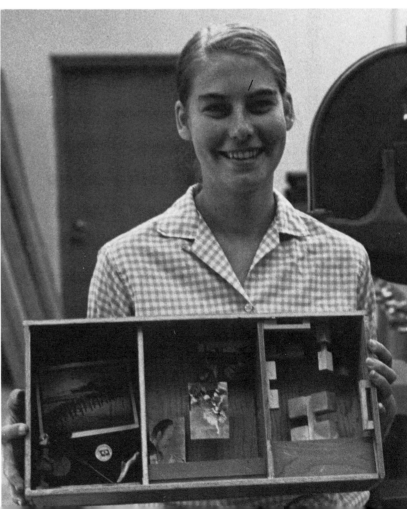

DIANNE PRESSLER

Coincidentally Dianne, too, used a drawer for the outer walls of her work. Her reason was a very personal one; since it was to contain things close to her that she had saved, she liked the idea of figuratively being able to *draw* them out from hiding. Note that she hasn't removed the knob. It helps tell the story, too.

The composition is composed in a vertical direction. When Dianne compartmentalized the box, she found it appropriate to curve the second shelf. It was an excellent decision for two reasons: it adds variety to the many right angles, and it also produces two unique stages, one with a curved floor and one with a curved ceiling.

The pieces placed in the compartments represent two of her special interests: art, especially the work of Rodin which is shown twice, and dance, which she's shown in photography and scupture. She's also put in the exposed workings of a music box—more interesting, I'm sure, than the box it came in.

The whole effect is softened with a collection of sea grass and shells plus a decorated egg.

The lettering on Dianne's T shirt was not planned as part of the assemblage but how right it looks, and sounds.

DENNIS DALE

Dennis's piece is unique among the five in that it's the only one not made of wood. A young man of his Age, he has opted for plastic.

The clear molded form was found on the scrap pile of a local industrial firm—original use unknown. Within it Dennis has affixed several common objects that add up to a story of man, his life, and fate. The cylindrical shapes down the right side are plastic pill containers. The large circular shape, which contains the photographic heads of many people, is from a radio speaker. The art reproductions are part of the allegory as are the egg and flag. A fine dramatic note is the brilliant red dripped paint down the back surface. It mixes with a pool of yellow at the bottom. One of the features I most admire is the way he has allowed the transparent quality of the plastic to remain evident. You can see through it in large areas: that creates interesting negative shapes against the positive silhouettes of solid objects. Because of its see-through quality it will be important to display this piece with care. It would be wrong, for instance, to place it in front of flowered wall paper or any other busy texture. I'd personally like to see it hung so one could view greenery at some distance in the background.

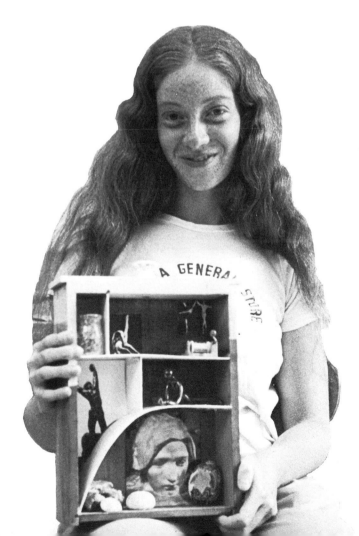

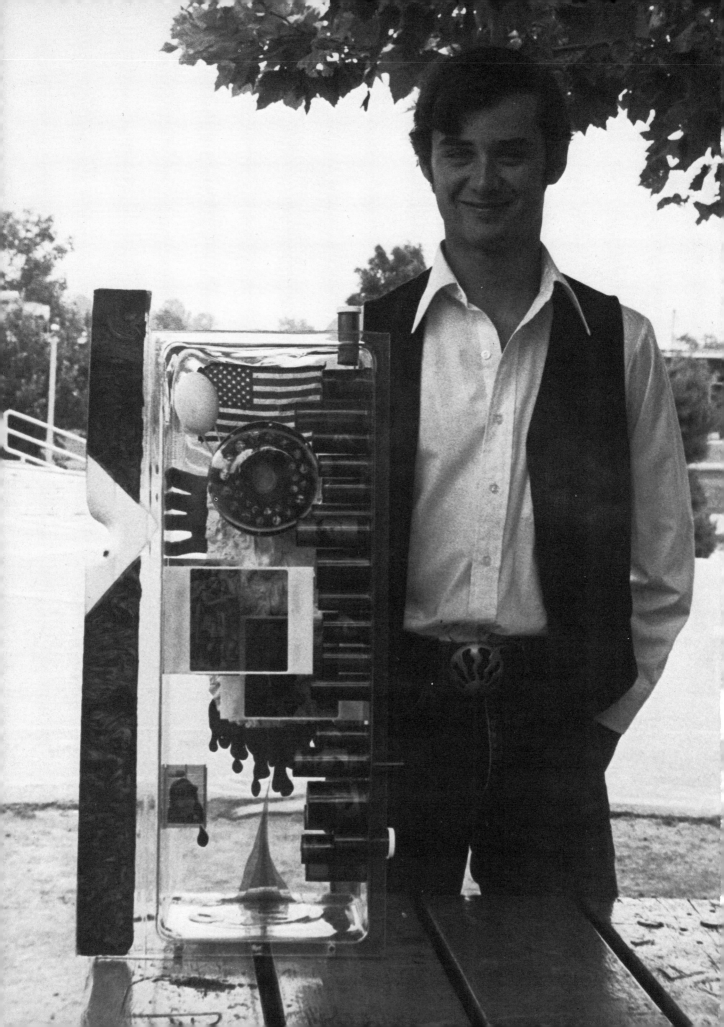